MW00633092

IMAGES
of America

CINCINNATI ON THE GO
HISTORY OF MASS TRANSIT

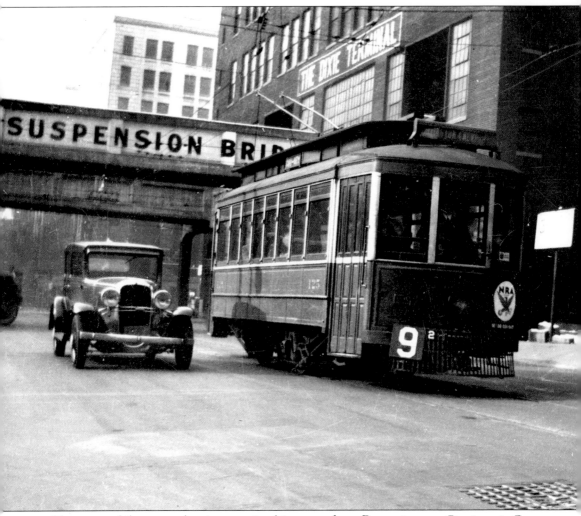

The automobile meets the streetcar in this scene from Depression-era Cincinnati. Green Line car 125 paces an automobile at Third and Walnut; the deck in the background carried streetcars from the Suspension Bridge to the Dixie Terminal. Automobiles would soon win the transportation war in Cincinnati, causing streetcars to eventually disappear from the streets forever. (Courtesy of the Walter Simpson Collection, through Cincinnati Chapter National Railway Historical Association (NRHS).)

(*Cover image*) Car number 1150 on Wilder Avenue makes the turn onto Warsaw in Lower Price Hill in 1949. This later art-deco style "PCC" streetcar, with its bright yellow paint job, was introduced in 1939 and offered unprecedented comfort and speed. The Carew Tower and the Central Trust tower in downtown Cincinnati can be seen in the background. (Courtesy of Pat Carmody, Cliff Scholes collection.)

IMAGES
of America

CINCINNATI ON THE GO
HISTORY OF MASS TRANSIT

Allen J. Singer

ARCADIA
PUBLISHING

Copyright © 2004 by Allen J. Singer
ISBN 978-0-7385-3337-7

Published by Arcadia Publishing
Charleston, South Carolina

Printed in the United States of America

Library of Congress Catalog Card Number: 2004109617

For all general information contact Arcadia Publishing at:
Telephone 843-853-2070
Fax 843-853-0044
E-mail sales@arcadiapublishing.com
For customer service and orders:
Toll-Free 1-888-313-2665

Visit us on the Internet at www.arcadiapublishing.com

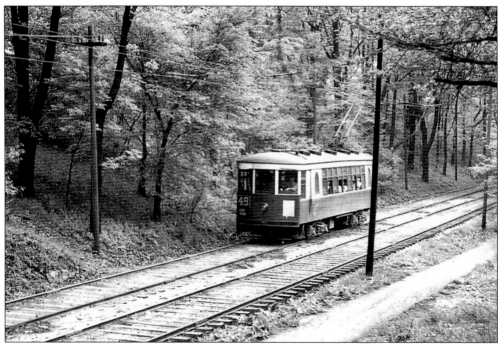

Cincinnati Street Railway "curve-side" car 2423 meanders through the scenic byways of Eden Park in 1947. The curve-side design was a key feature in reducing the car's weight, allowing them to consume less electricity. This car was a pioneer in lightweight streetcars. (Courtesy of the Russ Schram collection.)

CONTENTS

ACKNOWLEDGMENTS

Many different people have encouraged me since I first decided to write a companion book to *The Cincinnati Subway*. My wife Deanna supported me when I wrote that book and has continued to do so in all of my writing endeavors since. She patiently took care of everyday matters while I spent many weekends and evenings searching for just the right pictures, writing the captions, and preparing the book.

When I first began researching *The Cincinnati Subway*, I met a gentleman named Earl Clark, a local street railway and interurban historian and enthusiast. Earl was generous to me from the very beginning, happy to share his knowledge of Cincinnati rail history and his vast collection of photographs for "the book on the subway." We met on numerous occasions to discuss pictures I had chosen for the book and questions I had about streetcars and interurbans. Earl grew up riding and loving streetcars in both Covington and Cincinnati and more recently co-authored *The Green Line*, the complete history of public transit in Northern Kentucky. Through Earl, I met other rail transit enthusiasts who gladly offered pictures and information.

I first must thank Earl Clark, who spent several afternoons with me to review his many railway photographs. Earl lent some rare pictures from his collection and even pored through the final draft of the manuscript before submission. I also thank broadcaster Bill Myers, a sixth-generation Cincinnatian, who had proofread *The Cincinnati Subway* for me and proofread and suggested revisions for every chapter of *Cincinnati on the Go*. Bill contributed several 75-plus-year-old negatives that became wonderful, never before-published photographs that went into these pages.

Special thanks go to Alvin Wulfekuhl, Larry Fobiano, photographer Cliff Scholes, collector Fred Bauer, and steam railroad aficionado Dan Finfrock. Also, thanks go to Delores R. Birkle, Sue Erhart, the Greater Cincinnati Chapter National Railway Historical Association, the Cincinnati Railroad Club, and the Kenton County Public Library.

In addition to everyone who personally helped me create this book, I thank everyone who has enjoyed *The Cincinnati Subway* and appreciated the history of the Queen City enough to want to experience even more.

INTRODUCTION

We enjoy living in our contemporary world of interstate highways, fast automobiles, and supersonic jets. We don't think twice about hopping into our air-conditioned cars for a five-hour trip to another state, or even down the block to the grocery store. We live in an age of convenience, from the way we cook our food, to how we learn about the daily news and how we get to work every day. Our modern life is so totally ingrained that we cannot imagine living any other way. It is easy to forget that a century ago our grandparents and great-grandparents weren't as fortunate as we, having to live without blacktop roads and 75 mile-per-hour highway speeds.

No, their world wasn't as fast as ours is today. Many people did not own a car until Henry Ford introduced the affordable Model T. And even during the early years of the automobile, people were still hitching up teams of horses to their carriages for rides into town. Paved streets were rare; instead, muddy roads filled with long narrow trenches snaked across the countryside. Early travelers had little choice but to drive on primitive public and toll roads. Horse-drawn wagons and buggies shared these roads with the early automobiles, which were noisy, did not go very fast, and weren't 100 percent reliable transportation. All too often, stranded motorists were forced to swallow their pride and hire local farmers to pull their stalled vehicles out of ditches. Automobiles, of course, were only one of the many ways to get around a century ago.

Transportation on the rivers helped Midwestern cities grow fast. Huge riverboats steamed up and down the Ohio River carrying passengers, raw materials, and finished goods from all around the country. To make further use of the important water routes, the Miami-Erie Canal was built during the first half the 19th century. Cargo and passengers then could be carried to points further north from Cincinnati on narrow canal boats pulled by mules or horses and sometimes, electric locomotives. The canal ran right through the middle of downtown Cincinnati, providing convenient access to its services. By the time the canal was finished and being used regularly, railroad tracks had been installed all over the Midwest. Steam railroads then augmented the canal until the latter 1800s, a time when the canal was put out of business entirely by the railroads, which had completely taken over as the better choice in interstate travel.

Before the turn of the 20th century, cities all over the country began laying track into their streets and developing local mass transit systems: horse-pulled streetcars, cable cars, steam-driven streetcars, and inclined-plane railways to carry loaded streetcars up steep hills. In the late 1800s horsecars gave way to self-propelled streetcars when street railway companies electrified their systems. In 1888 electric streetcars appeared in Cincinnati.

After electricity became the choice method of power, railroad tracks of a different kind began appearing across the Midwest. In the 1890s interurban railroads, or "traction lines," began carrying passengers from city to city in individual high-speed cars, running on set schedules throughout the day. Steam railroads usually ran only twice a day and didn't offer as

much flexibility to early commuters. Interurban cars featured the added benefit of stopping at farmsteads and other out-of-the-way destinations and could travel to the heart of most cities. People all over the Midwest now had a cheap and easy way to travel almost anywhere they wanted, at speeds past 60 miles per hour.

After the arrival of the Model T in 1908, city-dwellers and country-folk alike bought their very own automobiles. Soon families found they could not afford to be without their "tin lizzies" and gradually stopped patronizing the interurban railroads. By the early 1930s all of the traction companies were out of business.

As more and more automobiles appeared on the streets, more and more roads had to be constructed. Downtown streets were widened for parking spaces, and buildings were demolished to make way for parking garages. New roads were constantly being built around the city and as cars started getting faster, new highways were built to accommodate the ever-changing needs of the motorists. Numerous gas stations, motor lodges, and restaurants soon were being built along major routes, changing urban landscapes forever. In every decade since, automotive technology has improved, styles have changed, and new highways and bridges have been built all across the country. All of which have been created to move American cars faster and faster.

Ours is indeed a world of wonders: new high-speed light rail systems are on the drawing boards to operate at speeds over 200 miles per hour. Thanks to a century of research and technological improvements, we can easily and quickly cross the country in cars, planes, and still even trains. And today, the cars in our own driveways are capable of attaining speeds unheard of so many years ago. A motorist of 1910 could never dream of driving as fast as we do on our endless miles of interstate highways. But we do it all the time. We have all been born too recently to have experienced a time when everything moved more slowly and when people weren't in such a hurry. It was quite a different world.

What was it like then, to ride on a steamboat down the Ohio River to Coney Island? To float on a flatboat through Cincinnati on the canal? To bounce along at a leisurely pace in a three-cylinder automobile? To catch a streetcar to work or to go shopping downtown? To travel on the interurban railroad from a tiny farm town to the big city? To ride in a passenger train from Cincinnati to New York and mingle in a lounge and a dining car and spend the night in a sleeping car—memories forever cherished? Or to ride a streetcar on the railway company's very last day of service? Most of us can only imagine such events in a time before cars became reliable and when folks always got around by riding streetcars and trains.

It all happened before our time, a hundred years ago.

One

OFF THE SHORES
OF THE OHIO

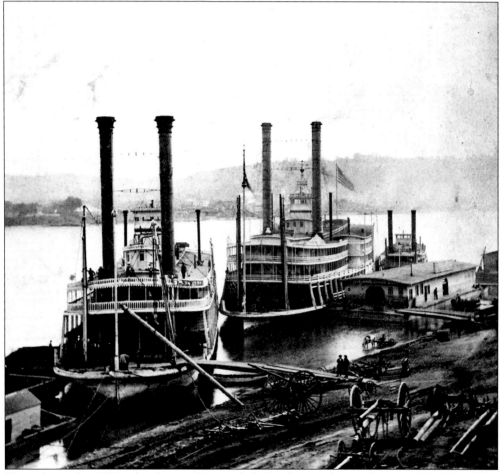

Throughout the 1800s, the Queen City exploded with growth as a direct result of the Ohio River being a major transportation corridor. Thousands of riverboats like these and many other varieties docked at the Public Landing in Cincinnati throughout the century. (Courtesy of the Kenton County Public Library.)

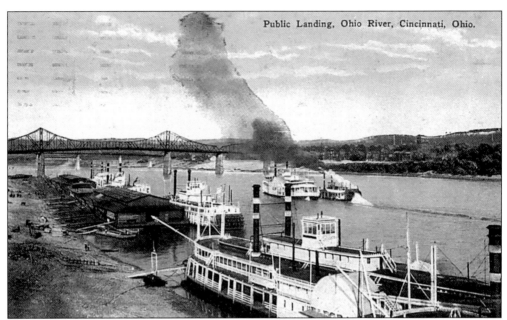

Public Landing, Ohio River, Cincinnati, Ohio.

A wider shot of the Public Landing in the early 1920s reveals more riverboats moving near the shore. The Central Bridge visible in the distance carried people and ground transportation between Cincinnati and Newport. Although quite a few boats are seen in this postcard, the busiest time in Public Landing's history was during the 1850s. (Courtesy of the Earl Clark collection.)

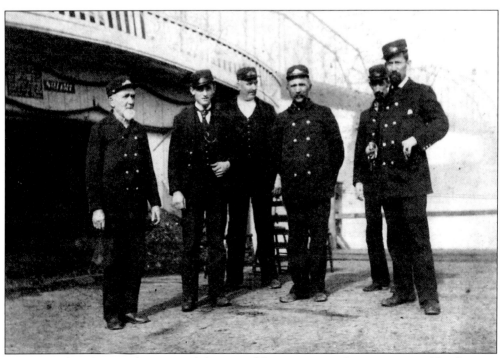

Passengers aboard a steamboat around the turn of the century may have met a crew like this one; the L&N Railroad Bridge is just beyond. (Courtesy of the Kenton County Public Library.)

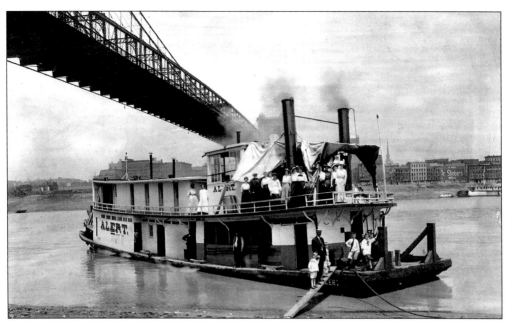

Steamboats began appearing on the Ohio River in the first quarter of the 1800s and offered reliable river transportation for most of the century. Except for a rare boiler explosion, trips on steamboats were safe, comfortable, and fun. Here, the Hatfield family is aboard the *Alert* as it docks at the Covington Landing, just beneath the Suspension Bridge near the turn of the century. (Courtesy of the Kenton County Public Library.)

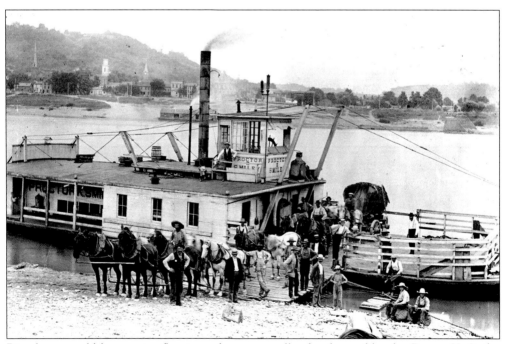

Riverboats could be massive floating palaces or smaller ferryboats, like the *Proctor K. Smiley* delivering its cargo opposite the Ripley shore 50 miles east from Cincinnati, *circa* 1900. (Courtesy of the Cincinnati Historical Society Library.)

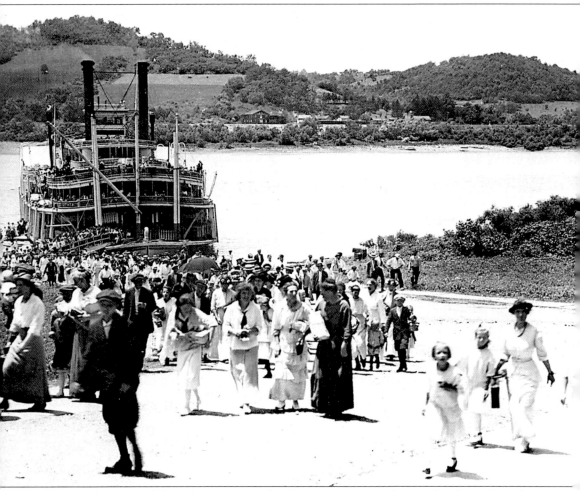

One of the most celebrated destinations for Cincinnatians was the popular Coney Island, an amusement park eight miles upriver, which offered daily trips on its own excursion boats. This steamboat, as well as Coney's *Princess*, made passage easy and fun for visitors and spared them a trip on the poorly maintained dirt roads in the pre-streetcar years. Coney Island's first *Island Queen* ran several trips a day from 1905 to 1922 between the park and downtown Cincinnati. Her old wooden hull caught fire in 1922, and the ship was completely destroyed. In this scene from 1910, throngs of passengers disembark from the first *Island Queen*, eagerly looking forward to a wonderful variety of entertainment at Coney Island. (Courtesy of the Earl Clark collection.)

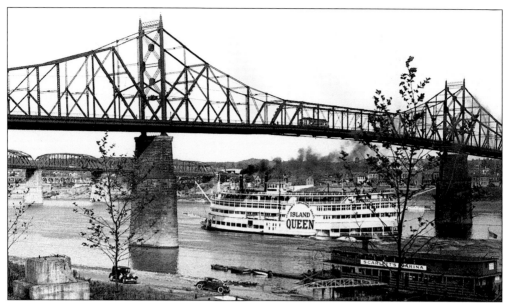

In 1925 a second *Island Queen* took over the daily pleasure runs up and down the Ohio River and continued until her fuel tanks exploded in 1947 during a refit in Pittsburgh. This boat could carry over 4,000 passengers and featured five decks with a huge ballroom, bar, cafeteria, arcade, and souvenir and refreshment stands. Here she crosses beneath the Central Bridge in the mid-1930s on her way back up to Coney Island. (Courtesy of the Dan Finfrock collection.)

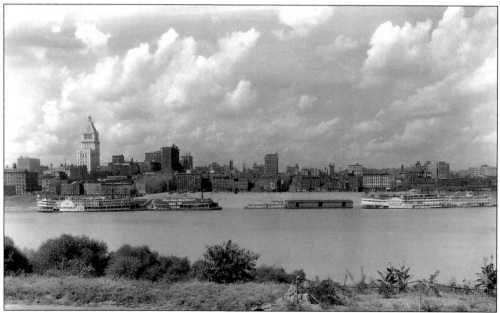

Although Cincinnati's riverfront would change over the years, the steamboats would never stop floating by. In this placid scene from around 1925, local residents standing on either riverbank could watch the *Cincinnati* and the *Island Queen* dock at the Public Landing. The Suspension Bridge is immediately to the left, just beyond the camera lens. (Photograph by W.T. Myers & Co., courtesy of Bill Myers.)

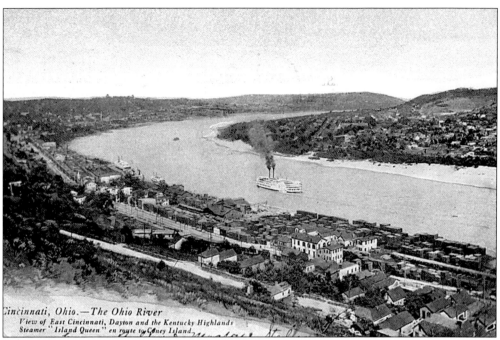

Cincinnati, Ohio.—The Ohio River
View of East Cincinnati, Dayton and the Kentucky Highlands
Steamer "Island Queen" en route to Coney Island

The *Island Queen* steams toward Coney Island, seen from Eden Park, *circa* 1905. The bathing beach in Dayton can be seen on the right hand side. (Courtesy of the Sue Erhart collection.)

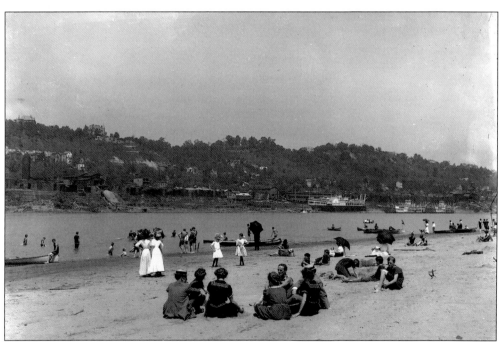

Many years ago people actually swam in the waters of the Ohio River while visiting the beaches on the Kentucky shores in Dayton and Bellevue. This rare photograph from around 1925 shows the kinds of bathing attire folks wore while swimming in the Ohio's nine feet of water (Photograph by W.T. Myers & Co., courtesy of Bill Myers.)

14

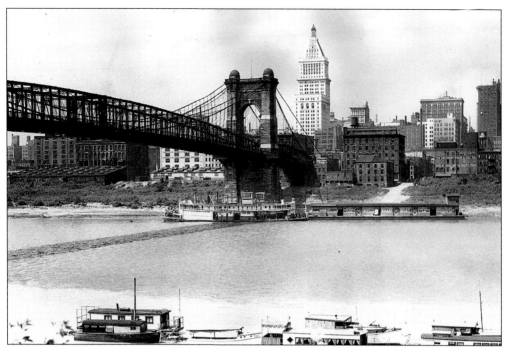

The Roebling Suspension Bridge opened in 1867, connecting Cincinnati with Covington. At 1,057 feet, it was the longest bridge in the world at the time. This 1929 photograph shows a boat preparing to dock at the Wifco wharf boat near the bridge. (Courtesy of the Dan Finfrock collection.)

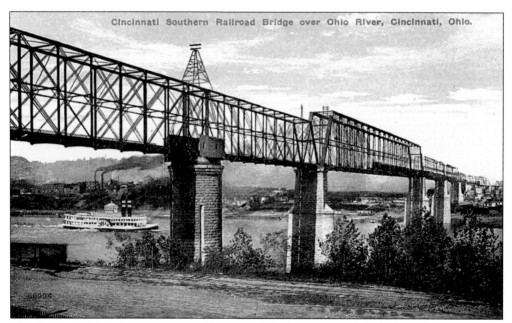

Cincinnati Southern Railroad Bridge over Ohio River, Cincinnati, Ohio.

The Cincinnati Southern Railway Bridge opened for business in 1866, linking the western side of downtown with Ludlow, Kentucky. The bridge still carries over 30 trains a day. (Courtesy of the Sue Erhart collection.)

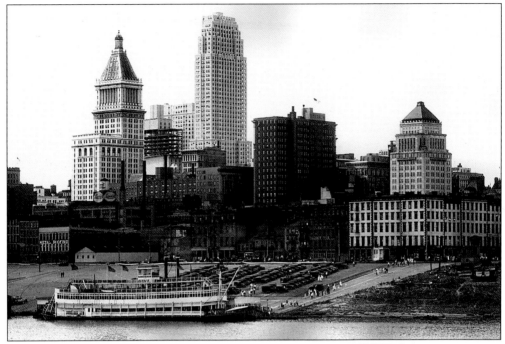

The Coney Island *Island Maid* (a backup boat for the *Island Queen*) unloads her passengers at the Public Landing in 1930. This boat would be destroyed in a fire in 1932. In the skyline the Carew Tower is under construction and has not yet had its windows installed. (Photograph by Ed Kuhr Sr., courtesy of the Dan Finfrock collection.)

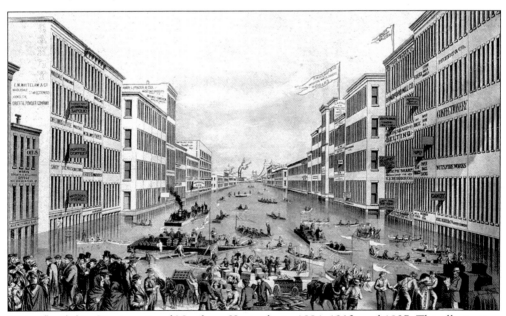

Major floods hit Cincinnati and Northern Kentucky in 1884, 1913, and 1937. This illustration of Walnut Street shows how Cincinnatians dealt with the 1884 flood whose waters had risen to 71.75 feet. (Courtesy of the Cincinnati Chapter National Railway Historical Association (NRHS).)

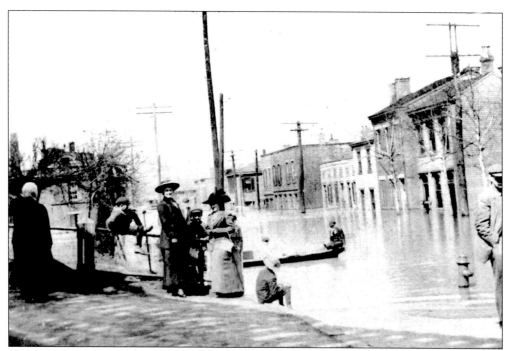

At the intersection of 4th and Main Streets in Covington in 1913, residents were forced to wait for rowboats to take them to temporary shelter until the flood waters subsided. (Courtesy of the Kenton County Public Library.)

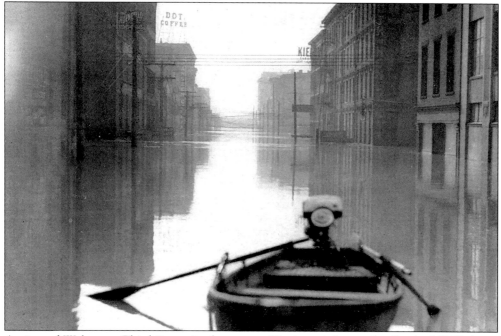

A view of Walnut at Third Street in downtown Cincinnati during the flood of 1937 shows the highest stage of water at 79 feet 11.875 inches on January 26. (Courtesy of the Cincinnati Chapter NRHS.)

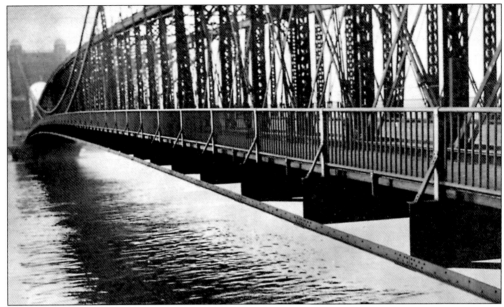

In 1937 the Ohio River rose dangerously close to the Suspension bridge, the highest it had ever been since the bridge was built. Just a few more feet and Ohio and Kentucky would have been totally cut off from each other. (Courtesy of the *Cincinnati Post*.)

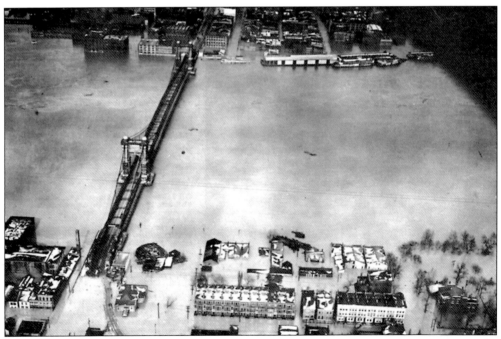

An aerial view of the Ohio River looking north shows the flooding into both sides of the Suspension Bridge in 1937. This was the only vehicular bridge to remain open between Pittsburgh and Cairo, Illinois. (Courtesy of the *Cincinnati Post*.)

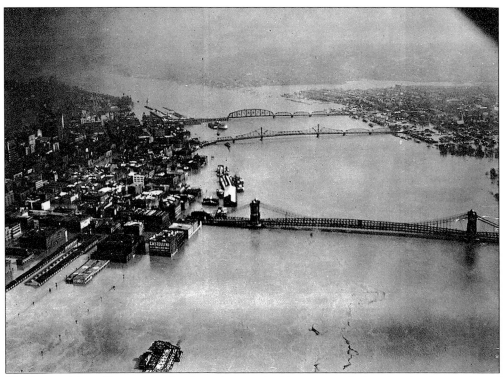

The far-reaching effects of the flood can be seen looking eastward, showing the devastation of both sides of the overflowing banks. (Courtesy of the *Cincinnati Post*.)

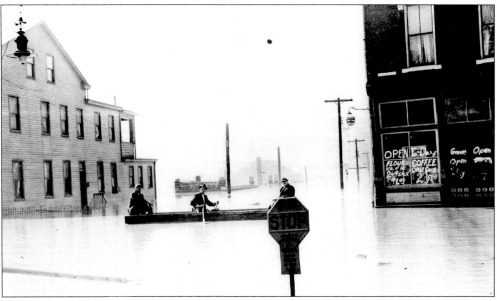

The situation was equally grim on both the Ohio and the Kentucky side as streetcars were replaced with canoes. The corner store to the right at 8th and Philadelphia in Covington apparently stayed open, selling Chase and Sanborn coffee and sacks of flour to passing boaters. (Courtesy of the Kenton County Public Library.)

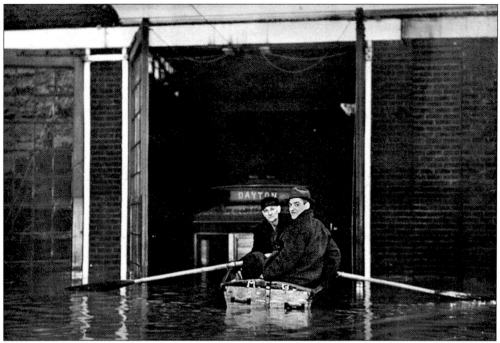

Green Line streetcars weren't going anywhere as inspectors entered the Newport car barn to find 68 cars almost completely engulfed by flood waters. (Courtesy of the Cincinnati Chapter NRHS, *O-K News*.)

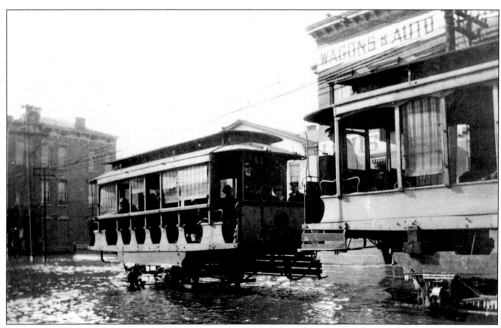

In 1937 the Cincinnati Street Railway employed special "highwater cars," built during the city's earlier floods, to carry passengers through the water logged areas of the Queen City. The motors were installed on the floor of the streetcars, and chain-drives propelled the wheels underneath. (Courtesy of the Earl Clark collection.)

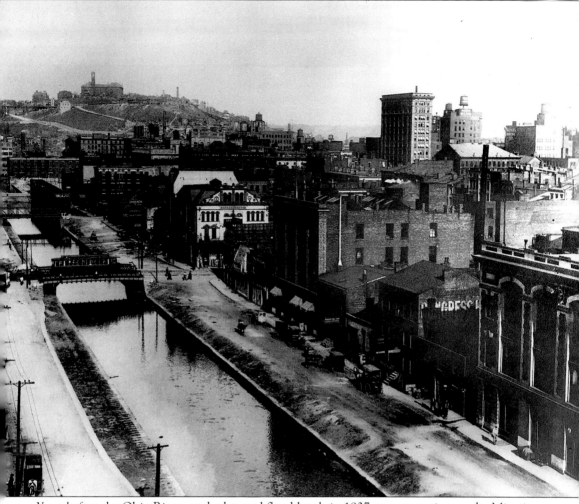

Years before the Ohio River reached record flood levels in 1937, transportation on the Miami-Erie Canal allowed passengers and goods to be moved all the way between Cincinnati and Lake Erie. The canal was built during the mid-1800s and provided water transport to slowly-moving boats. This scene shows the canal in downtown Cincinnati around 1905, at a time when the canal was rarely being used anymore. (Courtesy of the Dan Finfrock collection.)

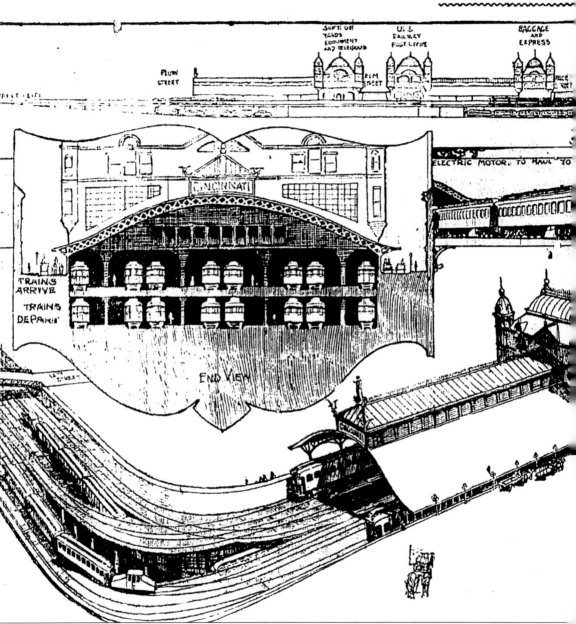

Many proposals of how to replace the obsolete canal were presented around the turn of the century. This rare illustration from January 1900 shows plans for an elaborate steam railroad terminal station four blocks long and 130 feet wide in place of the canal between Plum and Walnut Streets. The gigantic building, built of iron, would include all baggage and ticket offices, as well as hundreds of other business offices. A main depot situated between Vine and Race Streets would be "the most magnificent building of its kind in the world, only comparable to the Union Station at St. Louis." The depot would be six stories high, surmounted by a grand

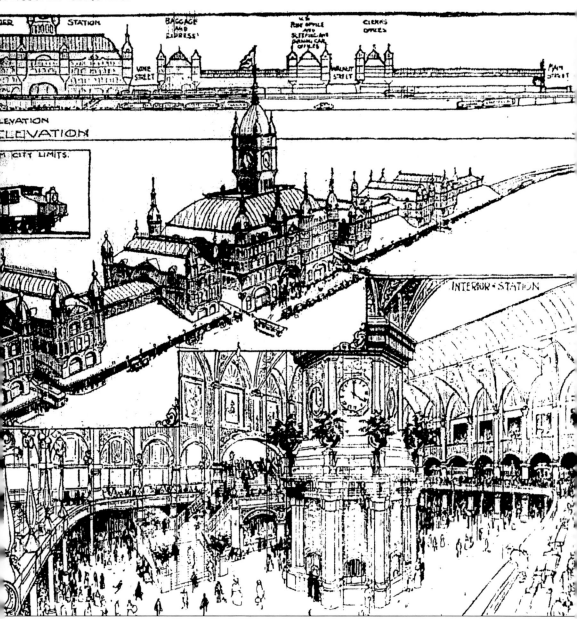

cupola from which every part of the city could be seen. In the cupola would be an 80-foot tall clock tower. The interior of the station was planned to be 250 feet long by 90 feet wide, with a dome 100 feet high. While this definitely was an intriguing idea, the grandiose station would have been too costly in 1900. This idea though was somewhat prophetic in two ways. In 20 years the canal would be converted into an unused subway. Union Terminal would be built in 1933 and would house all Cincinnati railroad stations in one building. Union Terminal was a gigantic, elaborate art-deco structure, similar in scope to this plan. (Courtesy of the *Cincinnati Enquirer*.)

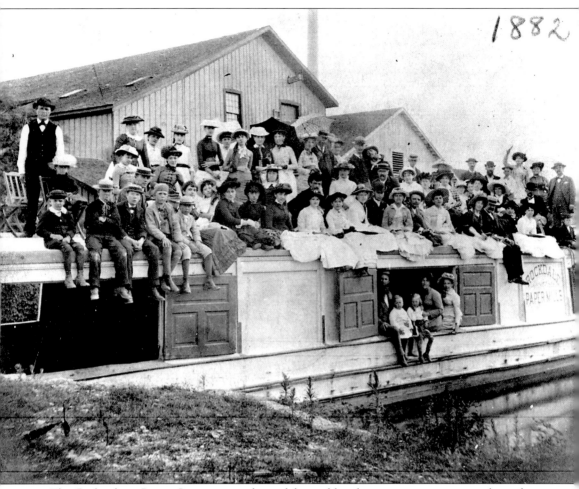

1882

The Richardson Paper Company used canal boats like this one to carry its products from Lockland to Cincinnati on the Miami-Erie Canal. Here, the Richardson family and friends enjoy an outing in 1882. (Courtesy of the Cincinnati Historical Society Library.)

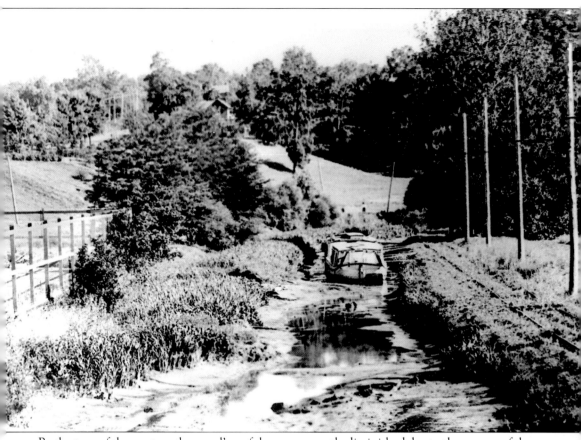

By the turn of the century the canal's usefulness was greatly diminished due to the success of the steam railroads. Tracks and overhead wires had been installed alongside the canal for an electric locomotive to pull the boats in this scene near Dayton, but the project had been abandoned. Now, a derelict canal boat just floats, forgotten in the murky waters, *circa* 1905. (Courtesy of the Earl Clark collection.)

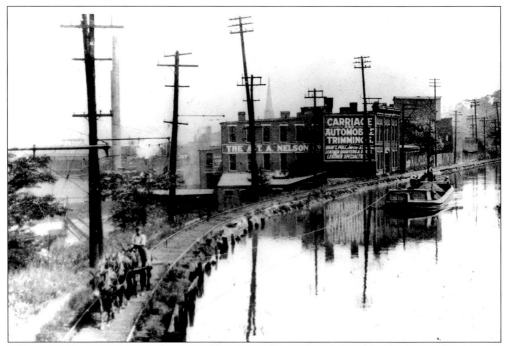

Closer to Cincinnati, a small team of horses walking along abandoned electric locomotive tracks pulls a boat down the canal near Brighton in 1902. A sign in the background advertises "trimmings" for carriages and the new automobiles. (Courtesy of the Earl Clark collection.)

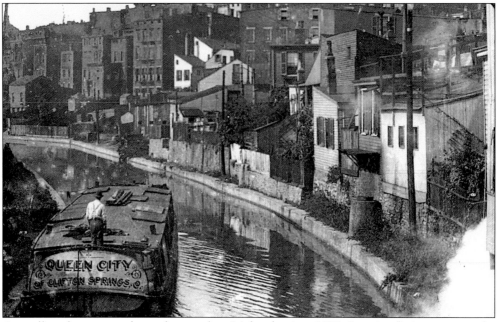

A small packet moves down the canal at Mohawk, *circa* 1890. Imagine living next to the Miami-Erie Canal and watching the boats float by your window every day. The sight of commerce and the rank smell of the canal were so common to folks downtown that the canal was hardly noticed. (Courtesy of the Earl Clark collection.)

Two

THE MIGHTY
STEAM LOCOMOTIVE

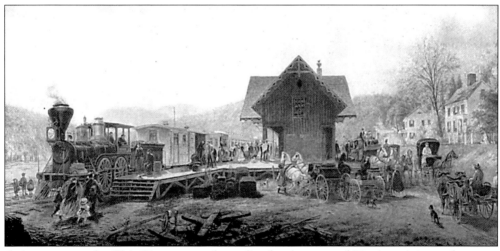

As important as the Ohio River was to the earlier development of Cincinnati, it was the steam railroad that pulled the Queen City into the 20th century. Railroads allowed cities and towns all over the country to thrive without the limitations of river transportation. People could now travel coast to coast much easier than ever before. In this typical railroad station in the 1860s, an assortment of wagons, ox carts, and a stagecoach meet the passengers on the station platform. (Courtesy of the Cincinnati Chapter NRHS.)

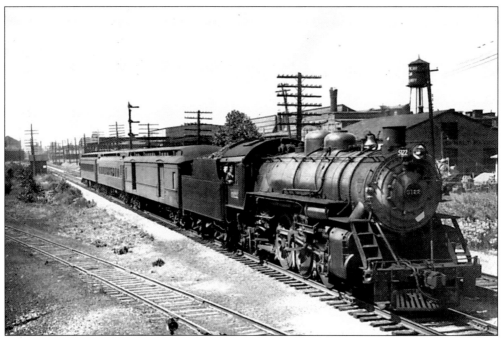

A Baltimore and Ohio train passes Old River Junction in Hamilton, Ohio, in the summer of 1931. (Courtesy of the Dan Finfrock collection.)

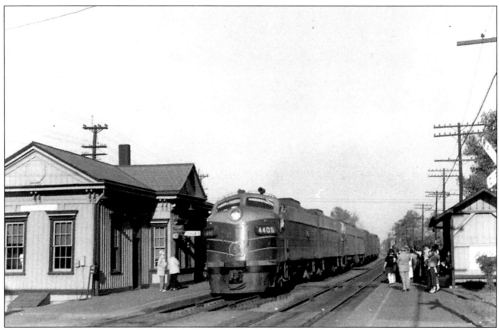

In 1957 the B&O station at Winton Place still was well patronized because of its convenient location and trackside parking area. It was a special treat for a youngster to be allowed to ride with a departing relative from Union Terminal to Winton Place. Meanwhile, the child's parents hurried to their automobile for the quick trip out to Winton Place to meet the train. (Courtesy of Kenneth H. Cooke, Cincinnati Chapter NRHS.)

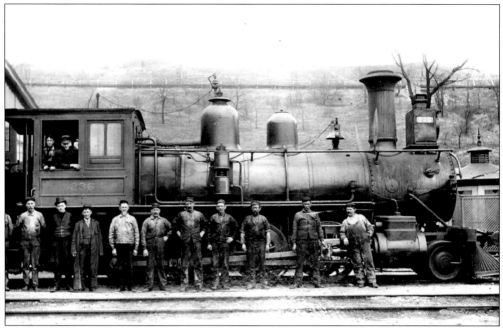

Working on the railroad was not a clean or glamorous job for the crew of this Pennsylvania Railroad train, stopped in Pendleton, Ohio, *circa* 1900. The hill behind the engine once flourished with grape farms. All signs of the railroad in this location are gone today. (Courtesy of the Cincinnati Railroad Club.)

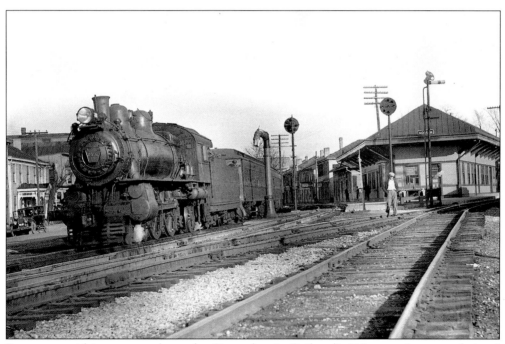

Passengers wishing to travel on the Pennsylvania Railroad's "Morrow Accommodations" commuter train would have boarded at this Morrow, Ohio, station in 1930. (Photograph by Ed Kuhr Sr., courtesy of the Dan Finfrock collection.)

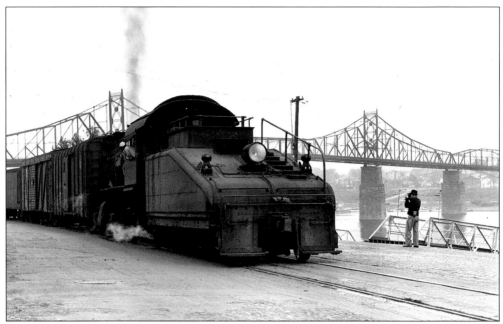

The Central Bridge and the Kentucky side of the river can be seen in the distance beyond this Pennsylvania Railroad switcher, *circa* 1948. The little locomotive moved train cars around the railroad yards at the riverfront, near what today is Sawyer Point. The Central Bridge was later replaced with the Taylor-Southgate Bridge in 1992. (Photograph by Sid Rindsberg, courtesy of the Dan Finfrock collection.)

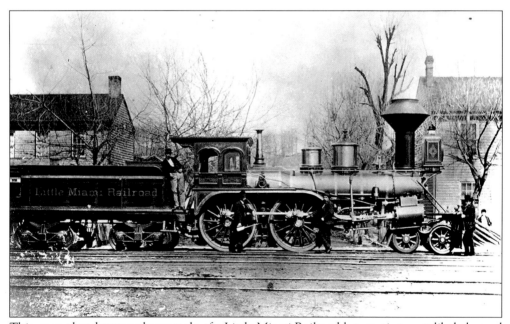

This unusual and very early example of a Little Miami Railroad locomotive most likely burned wood for fuel when this photograph was taken in Morrow in the 1860s. The balloon-shaped smokestack was fitted with a screen that prevented sparks and cinders from flying out and setting fire to the wooden railroad cars. (Courtesy of the Cincinnati Railroad Club.)

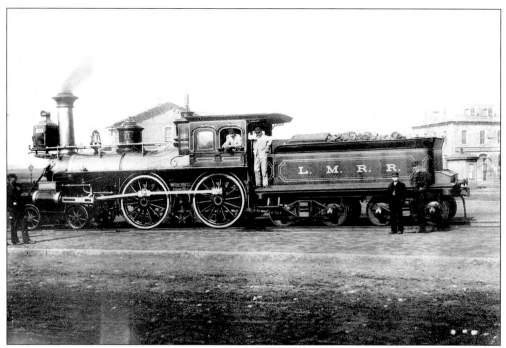

As railroad technology progressed through the 1800s, so did the style of the Little Miami locomotives, like this one seen in the 1890s. (Courtesy of the Cincinnati Railroad Club.)

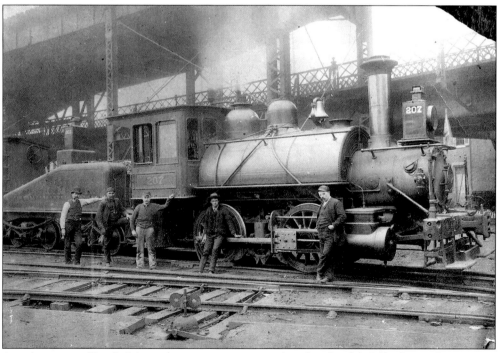

Another type of Little Miami locomotive is stopped under the C&O Bridge in Cincinnati, switching at the Little Miami freight house, *circa* 1890. (Courtesy of the Cincinnati Railroad Club.)

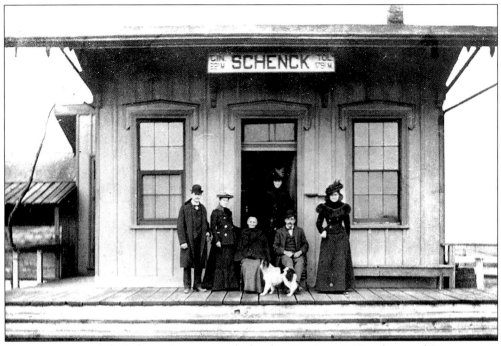

Six passengers and their dog wait expectantly for the Cincinnati, Hamilton and Dayton train to arrive at the station in Schenk, Ohio, *circa* 1882. This station was located where the present day State Route 4 passes under the railroad in Fairfield. (Courtesy of George Cummins, Dan Finfrock collection.)

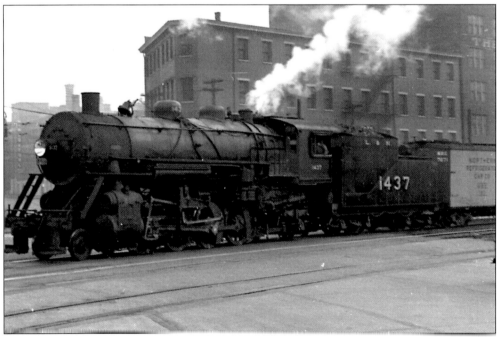

A Louisville and Nashville train steams along Cincinnati's west-side riverfront in the late 1930s. (Courtesy of Kenneth H. Cooke, Cincinnati Chapter NRHS.)

While traveling on a passenger train, such as the Louisville and Nashville Dixie Line, folks could enjoy a full breakfast after rising in the morning from the Pullman car. This menu dates from the early 1950s. (Courtesy of the Cincinnati Railroad Club.)

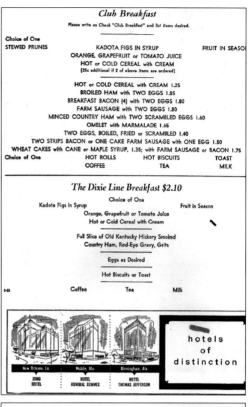

Club Breakfast

Please write on Check "Club Breakfast" and list items desired.

Choice of One
STEWED PRUNES KADOTA FIGS IN SYRUP FRUIT IN SEASON
ORANGE, GRAPEFRUIT or TOMATO JUICE
HOT or COLD CEREAL with CREAM
(25c additional if 2 of above items are ordered)

HOT or COLD CEREAL with CREAM 1.25
BROILED HAM with TWO EGGS 1.85
BREAKFAST BACON (4) with TWO EGGS 1.80
FARM SAUSAGE with TWO EGGS 1.80
MINCED COUNTRY HAM with TWO SCRAMBLED EGGS 1.60
OMELET with MARMALADE 1.65
TWO EGGS, BOILED, FRIED or SCRAMBLED 1.40
TWO STRIPS BACON or ONE CAKE FARM SAUSAGE with ONE EGG 1.50
WHEAT CAKES with CANE or MAPLE SYRUP, 1.35; with FARM SAUSAGE or BACON 1.75

Choice of One HOT ROLLS HOT BISCUITS TOAST
COFFEE TEA MILK

The Dixie Line Breakfast $2.10

Choice of One
Kadota Figs in Syrup Orange, Grapefruit or Tomato Juice Fruit in Season
Hot or Cold Cereal with Cream

Full Slice of Old Kentucky Hickory Smoked
Country Ham, Red-Eye Gravy, Grits

Eggs as Desired

Hot Biscuits or Toast

Coffee Tea Milk

hotels of distinction

New Orleans, La. Mobile, Ala. Birmingham, Ala.
JUNG HOTEL HOTEL ADMIRAL SEMMES HOTEL THOMAS JEFFERSON

A la Carte Service

FRUITS, ETC.		CEREALS	
Juice of Lemon with Water	.15	Dry or Cooked, with Cream	.45
Chilled Orange Juice	.35		
Stewed Prunes with Cream	.40	**BREAD, ETC.**	
Chilled Tomato Juice	.35	Hot Rolls or Biscuits	.20
Chilled Grapefruit Juice	.35	Dry or Buttered Toast	.25
Kadota Figs in Syrup	.40	Milk Toast	.50
Fruit in Season	.35	Wheat Cakes with Cane or Maple Syrup	.75

EGGS, OMELETS, ETC.

Boiled, Fried or Scrambled, two	.75	Broiled Ham with Two Eggs	1.50
Plain Omelet (3)	.85	Breakfast Bacon with Two Eggs	1.45
Poached on Toast, two	.85		

BEVERAGES

Coffee, Postum, Cocoa, Sanka, Tea35 Milk, Buttermilk25

For Members of our Armed Services holding Government Meal Orders we offer a special meal. Please consult Dining Car Steward.

An extra charge of 50 cents, per person, will be made for meals served out of dining car. This service is subject to delay during rush hours.

For the Children . . . A Special Menu is available.

Tax will be added to totals of checks in States where sales are taxable.

MEAL CHECKS—Please write on check each item desired. Waiter is not permitted to accept oral orders.

L&N Souvenir Playing Cards, Straight Deck 90c, Double Deck (2) $1.75

P. A. Wagner, Supt. of Dining Cars
LOUISVILLE & NASHVILLE RAILROAD, LOUISVILLE, KY.

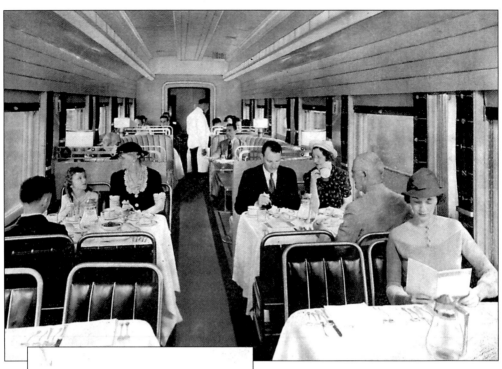

It's Smart
TO TRAVEL BY TRAIN

These Fine Trains to Serve You!

THE SOUTH WIND between Chicago and the East and West Coasts of Florida, every other day.

THE GULF WIND deluxe overnighter between New Orleans and Jacksonville, daily.

THE HUMMING BIRD daily Pullman-coach streamliner between Chicago, St. Louis, Cincinnati and the Mississippi Gulf Coast and New Orleans; through sleeper between Louisville and Chattanooga-Atlanta.

THE PAN-AMERICAN between Cincinnati and the Mississippi Gulf Coast and New Orleans, daily.

THE GEORGIAN daily overnight Pullman-coach streamliner between Chicago, St. Louis and Atlanta; through sleeper between Atlanta-Chattanooga and Louisville.

THE CRESCENT deluxe streamliner between New Orleans, Atlanta, Washington and New York, daily.

PIEDMONT LIMITED daily service between New Orleans, Mobile, Atlanta, the Carolinas, Washington and New York.

These famous L & N trains offer modern Pullman accommodations; comfortable reclining seat coaches; friendly lounge cars; unexcelled dining car service.

L&N
The Dixie Line

LOUISVILLE & NASHVILLE R.R.

During the early years of railroad travel, trains would stop at certain stations for a short break so passengers could grab a quick dinner at the station diner. With the advent of the railroad dining car in the 1860s, travelers never again had to leave the train to get something to eat. The dining car was set up much like a restaurant, complete with menus, waiters, and freshly-cooked meals. This photograph (above) shows a typical dining car of the 1940s, which offered comfortable seating, pastel-colored walls, tables covered with linen cloths, polished silverware, and even air conditioning. (Courtesy of the Cincinnati Chapter NRHS.)

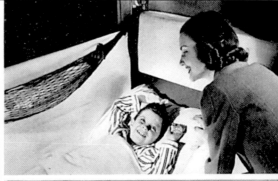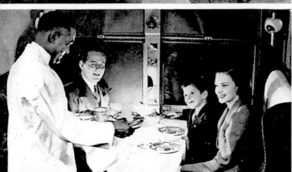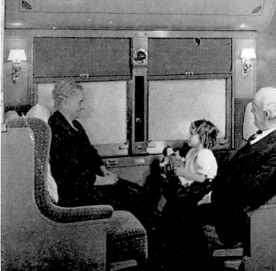

Standard Pullman cars of the 1940s could contain private quarters with two or three comfortable beds and a private toilet or sets of bunks with upper and lower berths equipped with electric lights, comfortable mattresses, sheets, blankets, and pillows. The cars were designed to eliminate jarring and shocks, and were built with sound-proof construction and thickly-padded carpets. For an average 300-mile overnight railroad trip, Pullman accommodations cost about $2.95 for a lower berth, $2.20 for an upper berth, $4.10 for a roomette for one, $5.80 for a bedroom for two, and $7.30 for a drawing room for one. (Courtesy of the Cincinnati Chapter NRHS.)

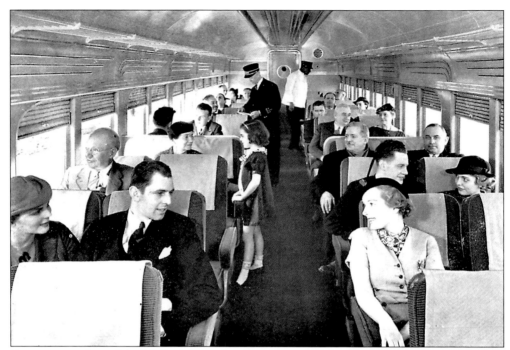

Passenger coaches of the 1940s delivered maximum comfort, with an average seating capacity of 77 passengers. The coaches were equipped with electric lights, double windows and insulated walls, individual cushioned seats with adjustable backs, padded aisle carpets, window blinds, and spacious baggage racks for carry-on luggage. Many high-speed streamliner coaches included radios, reading lights, water coolers, and stewardesses to tend to the passengers' needs. In this typical passenger coach, the conductor is collecting tickets while the porter helps passengers stow their luggage. (Courtesy of the Cincinnati Chapter NRHS.)

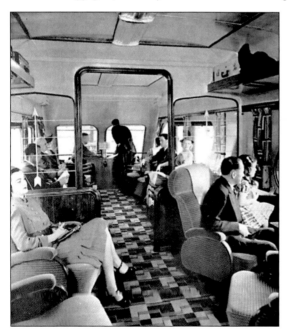

Riding on a passenger train in the 1940s was like visiting a moving hotel. The train provided sleeping quarters, dining facilities, and sometimes a lounge, club, and observation car similar to the lobby of an upscale hotel. But instead of having paintings on the walls, the train gave patrons a constantly changing panorama of American scenery. The overall atmosphere of the observation car was of sociability; it was a place for passengers to lounge and relax, listen to the radio, read, smoke, write, snack, enjoy a drink, or watch the passing scenery and chat with fellow passengers. (Courtesy of the Cincinnati Chapter NRHS.)

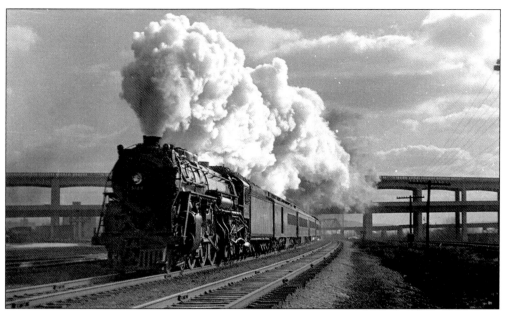

Smoke billows from the New York Central's "Ohio State Limited" passenger train bound for New York City in 1940. Among its many features were the comforts of an observation car. (Courtesy of the Dan Finfrock collection.)

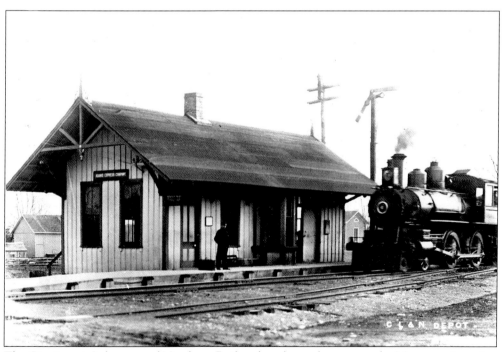

The Cincinnati, Lebanon and Northern Railroad made regular stops at the Mason station, *circa* 1905. (Courtesy of the Dan Finfrock collection.)

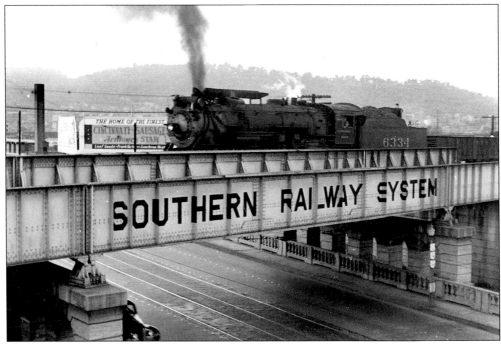

A Southern Railway steam locomotive crosses its bridge over the Eighth Street Viaduct in Cincinnati in 1942. The Southern Railway System, more formerly known as the Cincinnati, New Orleans and Texas Pacific, still is owned by the City of Cincinnati. By February of 1880 it was completed to Chattanooga which made connections possible throughout the South. (Courtesy of Kenneth H. Cooke, Cincinnati Chapter NRHS.)

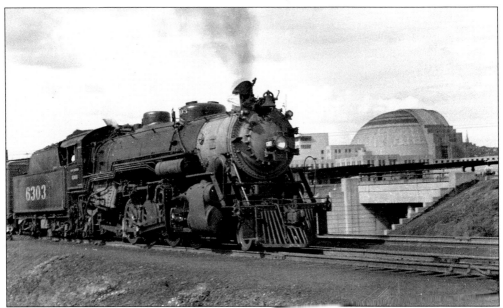

Cincinnati's new Union Terminal glistens in the background as a short Southern Railway freight train leaves the Gest Street yard in the 1930s. (Courtesy of Kenneth H. Cook, Dan Finfrock collection.)

Three

CARRIAGES, HORSES, AND INCLINES

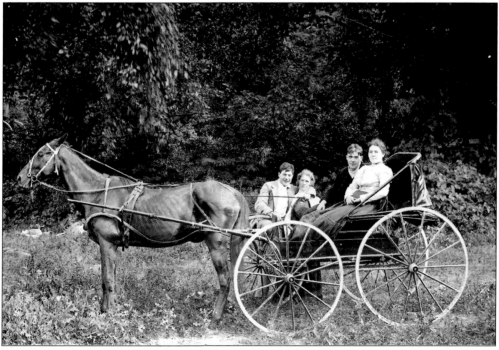

Two couples enjoy a pleasant day with their horse and buggy in the late 1800s. Most parts of Northern Kentucky and Cincinnati were without street railroads, and people continued to rely on their trusty horses and buggies. This buggy was pulled by one horse and included a convertible waterproof top. Wheels resembled the wooden ones used earlier on stagecoaches and wagons, although the front wheels were of smaller diameter than the rear wheels. Some folks continued using their buggies into the 1920s. (Courtesy of the Kenton County Library.)

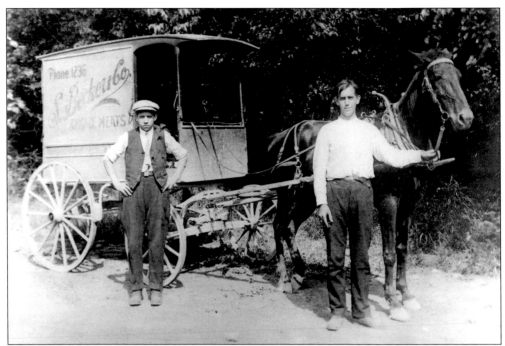

Horses pulling delivery wagons helped earn money for businesses. Around 1912 two employees of the S. Becker and Company Choice Meats, Frederick H. Kramer on the left and Jacob Fauz on the right, wait impatiently as the photographer does his work. (Courtesy of the Kenton County Public Library.)

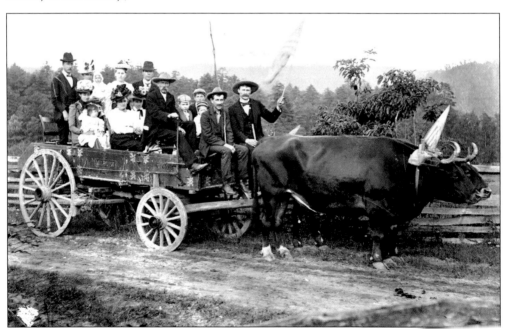

Oxen were hardy animals, strong enough to pull this heavy wagon full of 15 well-dressed people, on their way to hear the preaching of traveling evangelist Sam Jones, *circa* 1890. (Courtesy of the Cincinnati Historical Society Library.)

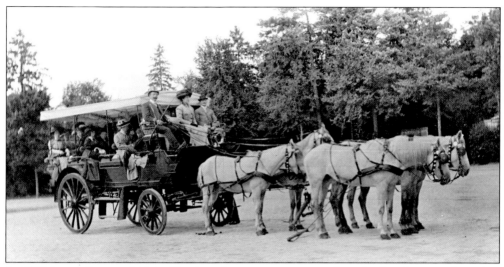

In 1859 iron rails were laid in Cincinnati streets to accommodate the first horsecar lines, but many areas had to wait quite some time for street railway service. And so, as it was in the country, one of the main methods to travel about the city continued to be the horse-drawn wagon. In this scene, a well-dressed family pauses in their trip across town aboard their covered, open-air wagon, *circa* 1890. (Courtesy of the Cincinnati Historical Society Library.)

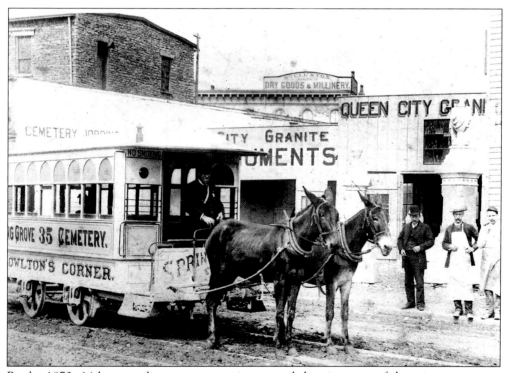

By the 1870s 14 horsecar lines were operating around the city, most of them in competition with one another. This one took riders to Spring Grove Cemetery from Knowlton's Corner, *circa* 1870. Later in 1880 the Cincinnati Street Railway Company formed when eight horsecar lines and two mule lines merged. (Courtesy of the Earl Clark collection.)

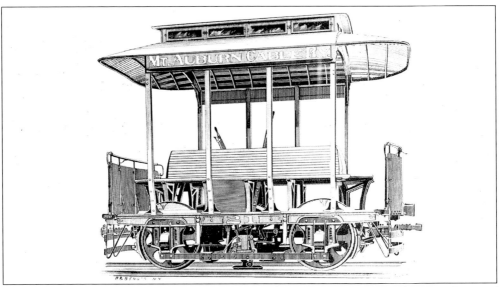

Since heavily-laden horsecars quickly wore out their "motive power," alternate forms of self-propulsion were explored. Cincinnati experimented with cable cars in 1885, modeling them after the cars in San Francisco. Cable cars were designed to pull former horsecars up Cincinnati's steep hills, finally giving horses and mules a needed rest. This cable "grip car" pulled its heavily loaded trailer up Sycamore Street hill. (Courtesy of the Earl Clark collection.)

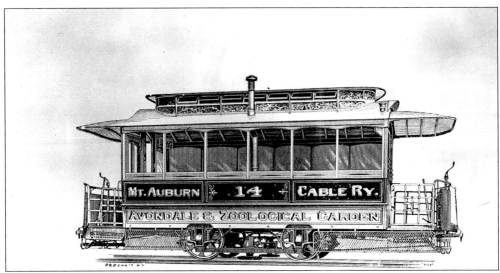

Cable cars offered several advantages over horsecars: horses had to be fed, watered, and rested at regular intervals; horses could not easily pull the packed cars up the hills; disease or sickness could paralyze a line, and horses deposited many obnoxious reminders of their presence. By contrast, cable cars were quiet-running and could travel at a steady eight miles per hour. (Courtesy of the Earl Clark collection.)

42

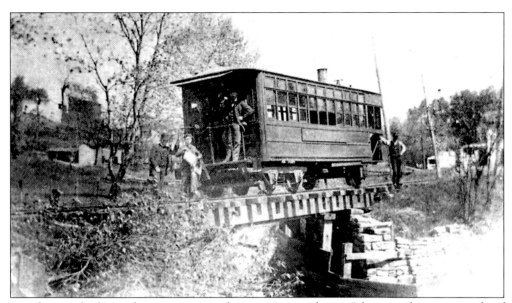

Another method was the steam-powered car or "steam dummy" line on the eastern side of Cincinnati during the late 1800s. The term "dummy" described a vehicle whose steam engine was situated inside the car to avoid frightening nearby horses. This steam dummy is crossing the bridge over Crawfish Creek, at what is now Mount Lookout Square. The dummy traveled from Pendleton Avenue to Mount Lookout along Crawfish Road (today's Delta Avenue), *circa* 1888. (Courtesy of the Earl Clark collection.)

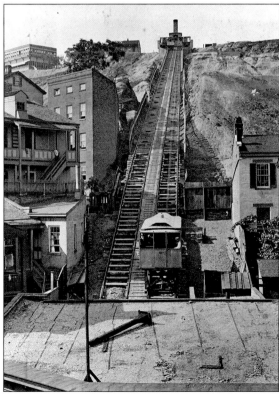

Near the end of the 19th century, Cincinnati's growing population sought to move from the overflowing basin to the suburbs developing on the surrounding hills. The challenge of the steep hills was overcome to a limited extent by the three cable car lines. But earlier in the 1870s, the high-tech solution was the construction of inclined plane railways, commonly called "inclines," to lift horsecars up the hills. In 1871 the Cincinnati Inclined Plane Company was formed to build the first incline. The Mount Auburn Incline, also referred to as the Main Street Incline, was completed in 1872. For a quarter of a century, it carried horsecars, and later on, electric streetcars until it closed in 1898. The square building to the left of the top of the incline was the Lookout House, a popular destination for incline travelers and city residents to drink, dine, and dance while enjoying a commanding view of the city below. (Courtesy of the Alvin Wulfekuhl collection.)

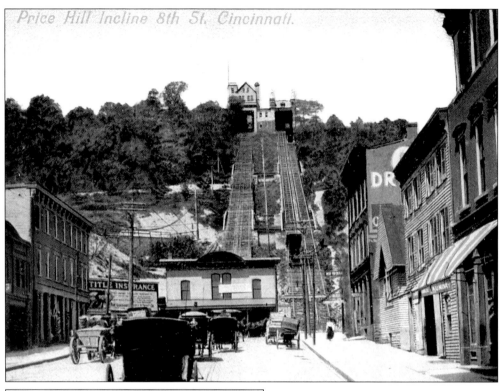

The city's second incline was built in 1874, carrying passengers to and from Price Hill in cabs affixed to the platforms. A second set of tracks on the right was built in 1876 to handle freight operation. The open platforms could carry three or four horse-drawn wagons. Many Price Hill homes and stores were built using materials hauled up by the incline. (Courtesy of the Fred Bauer collection.)

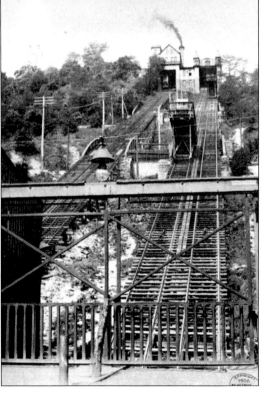

The gates are closed here at the foot of the Price Hill Incline (where West Eighth Street meets Glenway Avenue) in 1905. Stone piers and rugged wood beams supported the massive structure built onto the hill. One of the piers can still be seen today just above Warsaw Avenue. (Courtesy of the Earl Clark collection.)

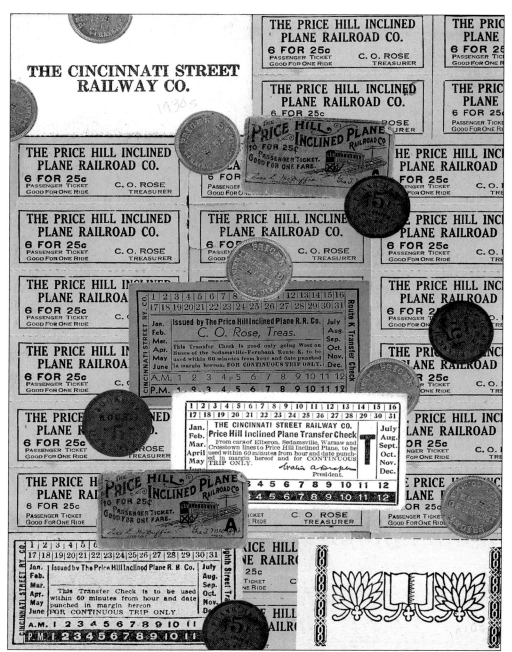

Passengers bought tickets and tokens to ride the inclines in the 1880s. The three larger tickets, issued in the 1930s and '40s, allowed riders to transfer to or from streetcars or buses on specific routes within certain time limits, just like today. One token seen here was good for admission into the Lookout House adjacent to the Mount Auburn Incline. (Courtesy of the Alvin Wulfekuhl collection.)

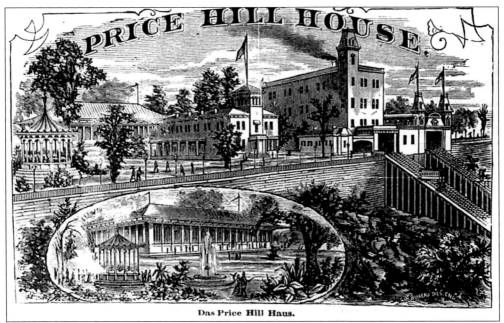

Das Price Hill Haus.

At the top of the incline was the Price Hill House, another popular resort and summer garden where folks could drink, socialize, and take in the panoramic view of the city and its hills. However, early patrons were limited to nonalcoholic drinks as mandated by the resort's chief financial backer, William Price, who wanted the resort to maintain a family-friendly atmosphere. This soon led to humorous references to "Buttermilk Mountain." In later years though, beer was added to the menu. Price Hill House burned down in 1899, but the garden and restaurant remained in business until 1938. (Courtesy of the Earl Clark collection.)

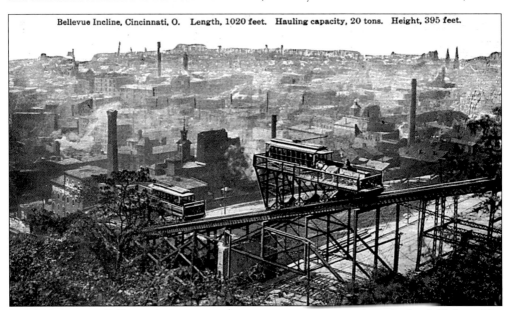

Bellevue Incline, Cincinnati, O. Length, 1020 feet. Hauling capacity, 20 tons. Height, 395 feet.

In 1876 the new Bellevue Incline started carrying passengers to the suburb of Clifton. The smoke that filled the basin of the city near the turn of the 20th century was seen as a sign of progress—not pollution. (Courtesy of the Earl Clark collection.)

46

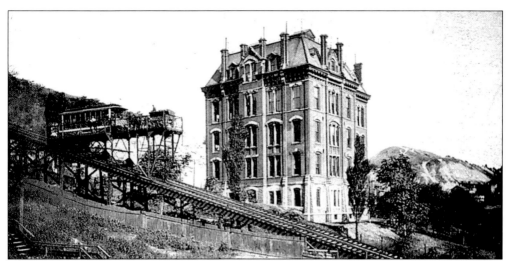

The official name of the Bellevue Incline was the "Cincinnati and Clifton Inclined Plane Railroad." As the platform ascended the hill, riders were given a close-up view of the Medical College adjacent to the incline. Medical student-jokesters periodically threw human body parts from windows to frighten female passengers on the incline platforms. (Courtesy of the Earl Clark collection.)

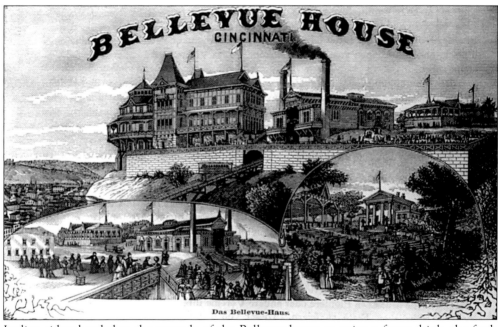

Incline riders headed to the veranda of the Bellevue house to enjoy a frosty drink, the fresh air, and a commanding view of the Queen City. These late 19th century resorts were built primarily to increase ridership on the inclines. And the plan worked. For a small admission fee, visitors could enjoy cold, Cincinnati-brewed beer, good food, great music, and varieties of games as they escaped the sultry heat of the basin. Its gradual decline in popularity led to its closing and remodeling for use as a car house near the end of the century. In 1901 the converted resort burned to the ground, destroying many of the cars stored inside. The incline continued operation until its closing in 1926. (Courtesy of the Earl Clark collection.)

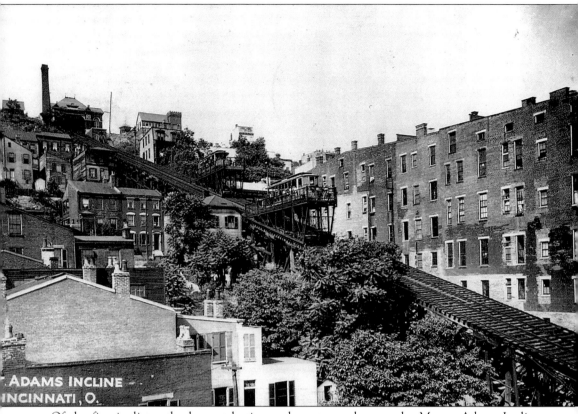

ADAMS INCLINE
INCINNATI, O.

Of the five inclines, the longest lasting and most popular was the Mount Adams Incline, which opened in 1876. It carried streetcars and pedestrians up to the top so riders could traverse the streets of Mt. Adams and experience the many beautiful attractions of Eden Park. In this 1910 scene the streetcar passengers, as they often did, have stepped out onto the platform to enjoy the view of Cincinnati "in motion" as they descend the hill. (Courtesy of the Fred Bauer collection.)

Another view of the Mount Adams Incline *circa* 1905 shows a streetcar ready to leave the platform and continue on its route. This incline operated 19 hours a day, with six trips per hour, at two minutes and twenty seconds per trip. And just like most of the other inclines, the Mount Adams Incline offered its own hilltop resort, the Highland House, until the turn of the century. (Courtesy of the Larry Fobiano collection.)

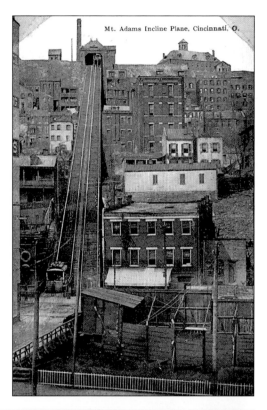

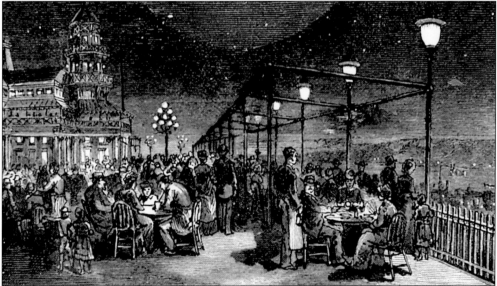

In this typical scene from around 1880, visitors to the Highland House enjoy the pleasures of fine food and drink beneath the unpolluted evening sky. People came from every direction to experience its many attractions: the dining hall; the large, wooden pavilion that featured concerts and light opera; a canopied summer garden; bowling alleys; a wine cellar; a beer bottling plant; and even the Belvedere, an opera house just next door. (Courtesy of the Earl Clark collection.)

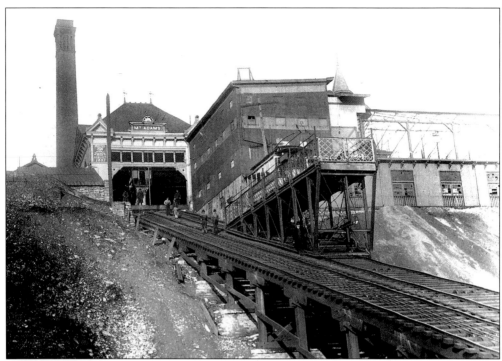

The steam engines have been halted as crews inspect the track and platform to keep the Mount Adams Incline in good running order, *circa* 1900. (Courtesy of the Dan Finfrock collection.)

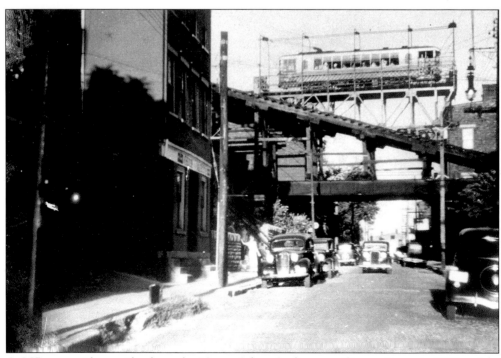

A CSR curve-side car rides down the Mount Adams Incline over Oregon Street in 1940, a sight so common that most people paid little attention. (Courtesy of the Earl Clark collection.)

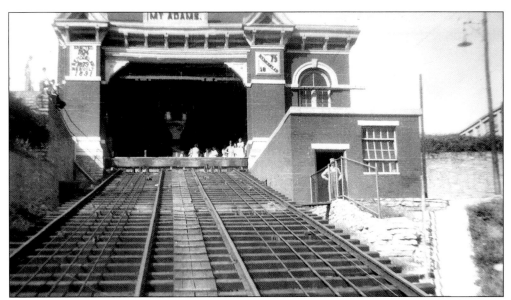

Over the years many passengers would eagerly wait in long lines to ride up and down on the Mount Adams Incline, as evidenced by this 1944 view. Little did they know that in just four years this jewel in the Queen City's crown would be only a memory. (Courtesy of C.R. Scholes, photographer.)

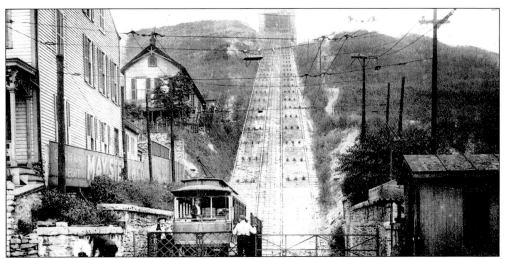

The Cincinnati Street Railway Company itself built only one incline: the Fairview Incline, which went into service in 1894. This scene *circa* 1910 shows a Crosstown streetcar ready to ride the platform to the top as its opposite number is to be lowered, providing a counterbalance. By 1921 the incline was in need of major, expensive repairs so it was closed to streetcar traffic. The Crosstown Line was split in two, and passengers had to transfer at both the top and bottom of the incline. Instead of rebuilding the incline, the company spent $85,000 to build a road around Fairview hill. This new portion of McMillan Street, opened in December 1923, bridged the difficult terrain between McMicken Avenue and Ravine Street. Although the incline continued to transport foot passengers in fixed cabs, it closed forever on December 24, 1923. The next day, the first Crosstown cars began using the new hill route. (Courtesy of the Fred Bauer collection.)

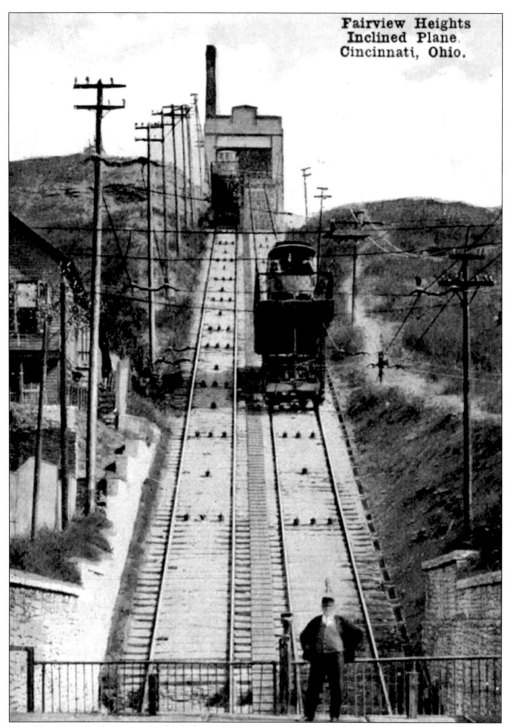

Fairview Heights
Inclined Plane.
Cincinnati, Ohio.

The Fairview Incline overlooked the Miami-Erie Canal and westward across the Millcreek Valley where the Western Hills Viaduct stands today. This incline transported the recently begun Route 23 electric streetcars between McMicken Avenue and Fairview Heights. (Courtesy of the Kevin Grace collection.)

52

Four

THE HORSELESS
CARRIAGE

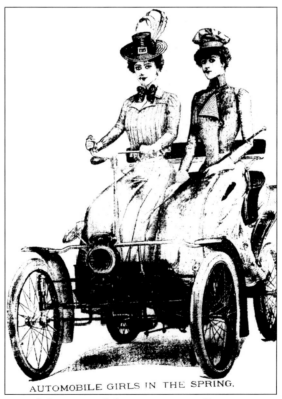

AUTOMOBILE GIRLS IN THE SPRING.

The 20th-century design of the automobile was not new. Dreamers, scientists, and inventors were designing and constructing vehicles that ran on their own power as early as the 17th century. These primitive vehicles were propelled by such fuels as steam, coal gas, and electricity. By 1900 car builders had become established in cities all around the country, selling their expensive new contraptions to those who could afford them, which almost invariably meant the wealthier citizens. Electric-powered automobiles, or "electrics," were especially enjoyed by rich, young "society women," who preferred the cleaner, quieter-running electric car. This rare illustration from early 1900 shows a pair of "automobile girls" enjoying their expensive new toy on a pleasure ride. (Courtesy of the *Cincinnati Enquirer*.)

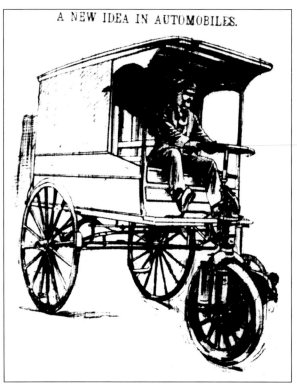

A NEW IDEA IN AUTOMOBILES.

Another suggested idea on how to better propel a vehicle was to install a motor on the front wheel of a three-wheeled carriage, seen in this illustration from early 1900. (Courtesy of the *Cincinnati Enquirer*.)

After the turn of the century many styles and makes of automobiles were produced, making identification oftentimes difficult. This vehicle, with its curved dash, is likely an Oldsmobile roadster from 1901. (Courtesy of the Cincinnati Historical Society Library.)

An Oldsmobile roadster, assuming that's what this car is, contained two seats and a one-cylinder, three-horsepower engine. It sold for $650. (Courtesy of the Cincinnati Historical Society Library.)

Yet another ambitious entry into the competition was this single-seat auto, possibly another early Olds product, *circa* 1902. (Courtesy of the Cincinnati Historical Society Library.)

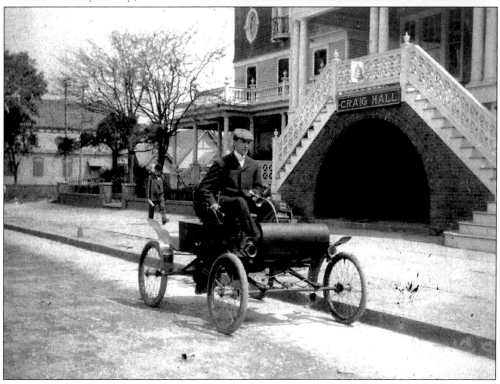

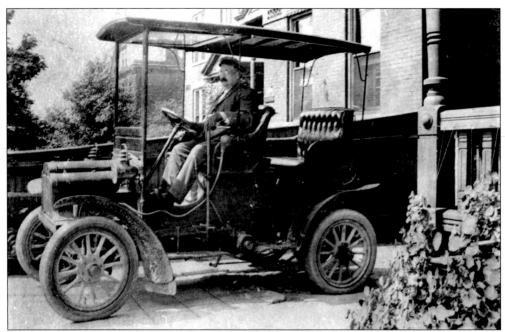

Henry Ford began automobile production in earnest when he formed the Ford Motor Company in 1903. This car could be an early Ford product, *circa 1905*. (Courtesy of the Cincinnati Historical Society Library.)

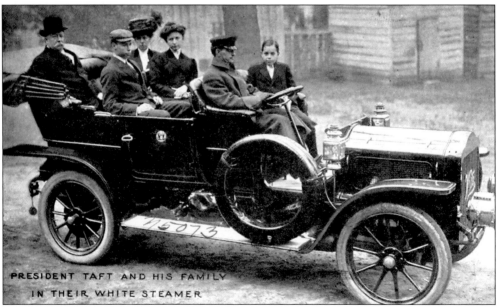

PRESIDENT TAFT AND HIS FAMILY
IN THEIR WHITE STEAMER

In 1909 a Cincinnati car dealer mailed out postcards advertising the White steam-powered automobiles, depicting former Cincinnatian President Taft and his family riding the steamer. The message on the card read, "They are good enough for Uncle Sam, why not you? Steam or gasoline, we have both. Call or write for a demonstration." Although the steamers nearly required an engineer to run them, they were actually more dependable and faster than their gasoline-powered siblings. (Courtesy of the Kevin Grace collection.)

This primitive automobile appeared on the streets of Latonia, (the southern suburb of Covington) *circa* 1905. It featured an exposed engine, a chain drive, and white rubber tires. Pictured from left to right are Dudley Gray, Etta Earle, and Howard Johnson. (Courtesy of the Kenton County Public Library.)

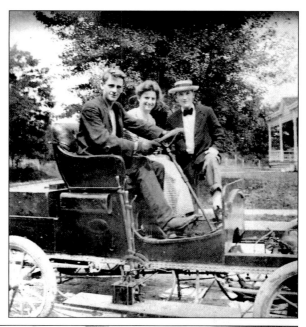

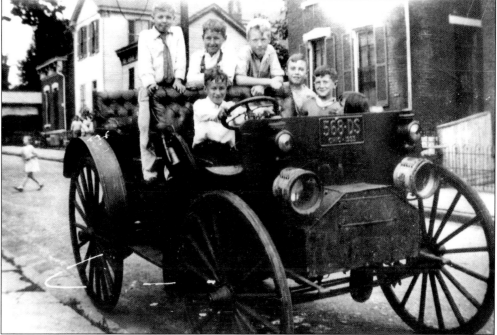

Not all early automobiles were factory originals. In some cases, a car was cobbled together from parts assembled from an owner's previous cars, as it seems in this case. Although the license plate reads 1935, the lineage of this automobile likely dates to around 1905. The tires look as though they are made of solid rubber, with the rubber completely gone from the driver's-side wheel. Steering wheels on the earliest automobiles were usually placed in the location seen in the photograph. It was believed that the driver could exit the vehicle more safely when parking at the curb rather than if the steering wheel were on the other side. Henry Ford later standardized the left-side placement. (Courtesy of the Kenton County Public Library.)

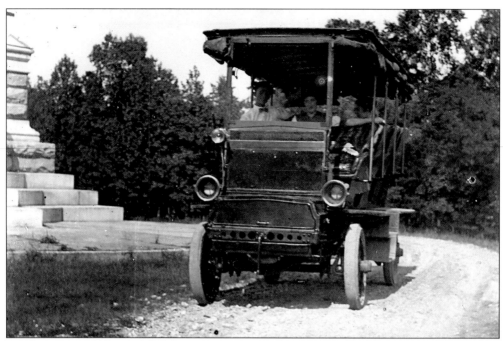

Small trucks could be modified for use as passenger vehicles as in the case of this early bus from *circa* 1908. This is likely a truck that has been fitted with bench seats and a canvas roof, now carrying passengers around Cincinnati/Northern Kentucky for a small fare. Designated routes would not have existed, and the service very likely was unreliable. (Courtesy of the Kenton County Public Library.)

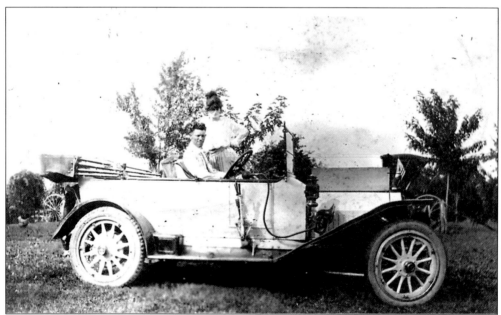

The Locomobile company produced speedy, but expensive, automobiles from 1899 to 1929. This version had a convertible roof and kerosene cowl headlights. Pictured in the seat are Earl Clark Senior and his wife Elizabeth Childs Clark in 1919. (Courtesy of the Earl Clark collection.)

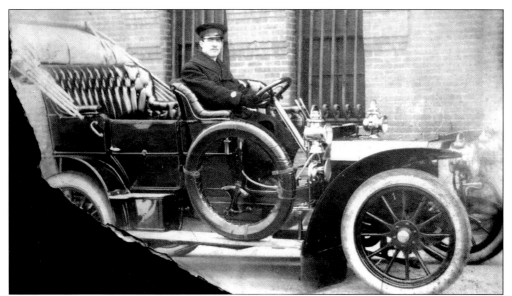

In the early 1920s Mary Emery, widow of wealthy Cincinnati industrialist Thomas Emery, dreamed of a new community for Cincinnati, a carefully planned village to resemble the environment of an English garden city. Her idea blossomed into the renowned Mariemont, a collection of stately Tudor-style homes in an old-world-style village. Mary Emery spent her time traveling between New York, Rhode Island, and Cincinnati in her *circa* 1907 automobile, chauffeured by the author's great-grandfather Charles A. Singer, posing here in the driver's seat. (Courtesy of the Dolores R. Birkle collection.)

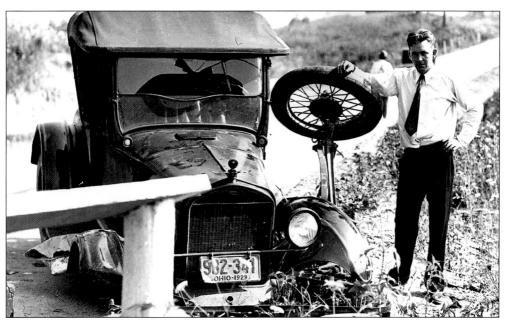

Driving mishaps have occurred in every year since the automobile was first introduced. This poor fellow has managed to completely destroy the car's front end in a crash. The photograph is thought to have been taken south of Newport, Kentucky, in 1929. (Photograph by Ed Kuhr Sr., courtesy of the Dan Finfrock collection.)

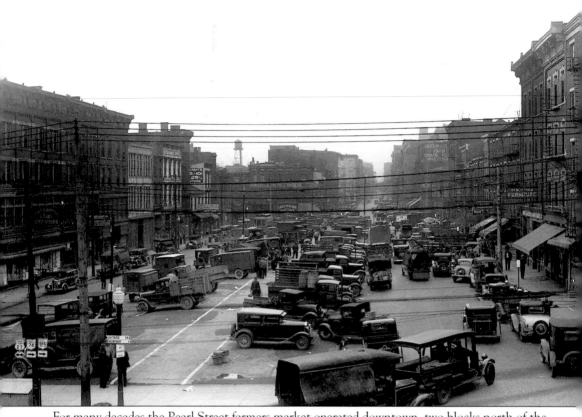

For many decades the Pearl Street farmers market operated downtown, two blocks north of the Ohio River, into the 1950s. Local farmers and other merchants met here to sell their wares off the backs of their cars and trucks. Rows and rows of 1920s vintage automobiles and trucks are seen on Pearl Street, looking west from Broadway, *circa* 1934. (Photograph by W.T. Myers & Co., courtesy of Bill Myers.)

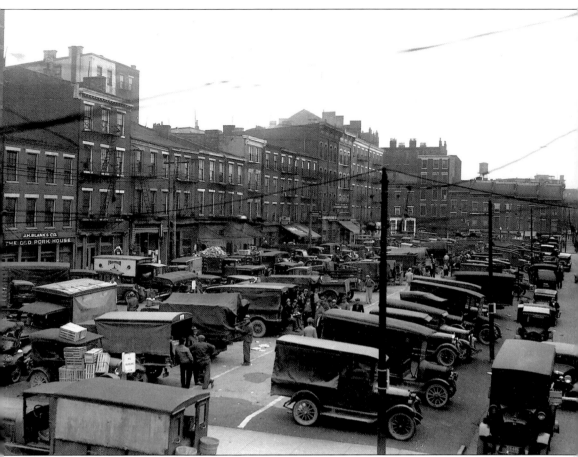

Looking east from Sycamore, activity at the Pearl Street Market *circa* 1934 is light this afternoon, with more people standing around talking than actually selling anything off of their trucks. The busiest time for the market was early morning when shoppers would arrive early and choose the freshest produce. By afternoon the fruits and vegetables had been sitting out in the day's heat, being thumped and prodded by hundreds of dirty hands. (Photograph by W.T. Myers & Co., courtesy of Bill Myers.)

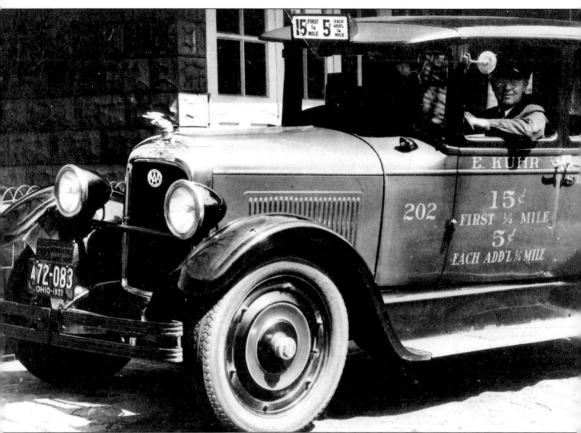

Visitors arriving by railroad to the Queen City might not know which streetcars to take to their hotels, so they would hail a taxi. This 1928 Studebaker taxi carried fares around Cincinnati for rates that were typical in 1932. Sitting in the driver's seat is Ed Kuhr, the photographer of several pictures in this book. (Courtesy of the Kenton County Public Library.)

Five

ALONG CAME
A TROLLEY

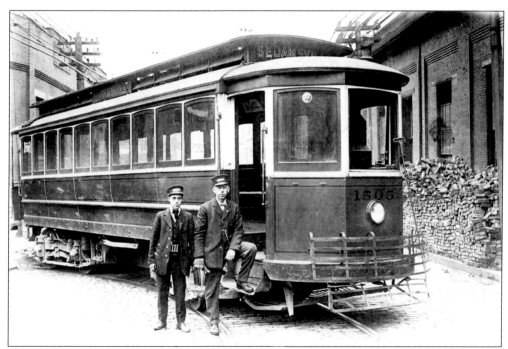

Electrification of streetcar lines in the late 1880s around Cincinnati revolutionized the way people were transported throughout the city. Horses were soon released from service permanently as streetcars, or "trolleys," took over the rails. A conductor and motorman pause in front of car 1505 in 1910. The conductor, who can always be identified by his coin changer, looks barely old enough to be out of high school. (Courtesy of the Fred Bauer collection.)

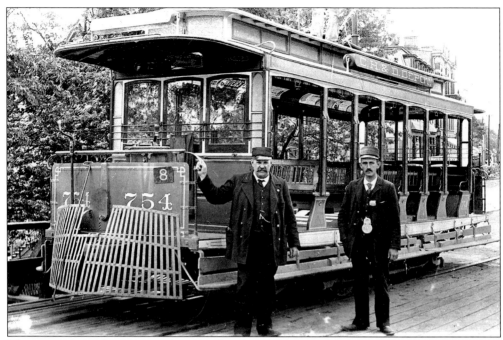

The motorman and conductor take a brief break at the corner of Eastern Avenue and Carrel Street around 1896. In the days before air conditioning, open-air summer cars like this were understandably popular during the warm-weather months. (Courtesy of the Earl Clark collection.)

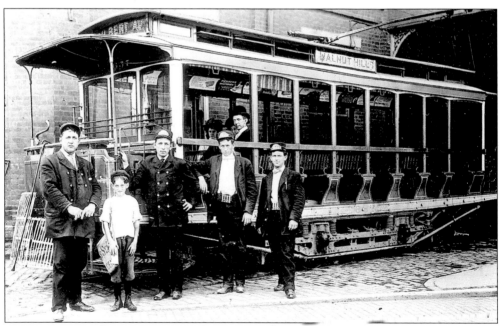

Streetcar crew and a *Times-Star* newsboy (*Extree! Extree!*) pose in front of an open air-car at the Blair Avenue car barn at Montgomery Road in Evanston in 1905. (Courtesy of the Earl Clark collection.)

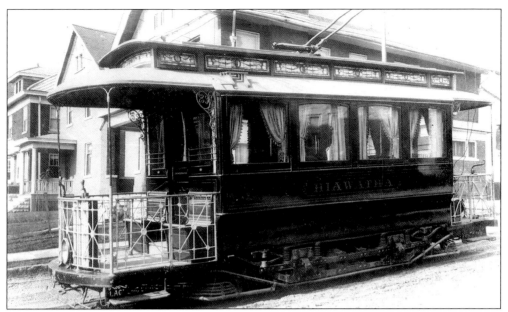

A CSR "parlor car" could be chartered by private groups for sightseeing around the city. They could also be used for entertaining out-of-town friends and relatives and for weddings, anniversaries, birthday parties, and even funerals. Parlor cars were given names, such as the *Hiawatha* seen in Mt. Auburn in 1915. (Courtesy of the Earl Clark collection.)

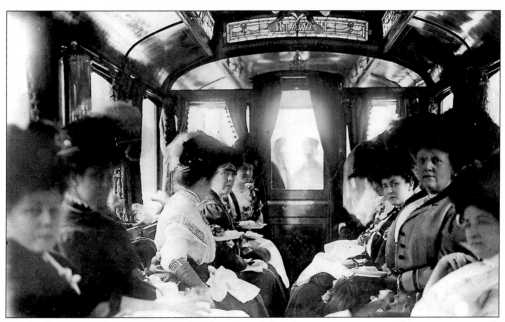

Inside the *Hiawatha*, passengers who have paid for their private car could enjoy a special, luxurious ride. The parlor car was equipped with overstuffed wicker chairs, curtained windows, wall-to-wall carpeting, decorated ceilings, mahogany paneling, and colored glass in the clerestory seen along the ceiling of the car. Although many members of the public loved to charter parlor cars, the CSR found them altogether too unprofitable and canceled them after 1915. (Courtesy of the Kenton County Public Library.)

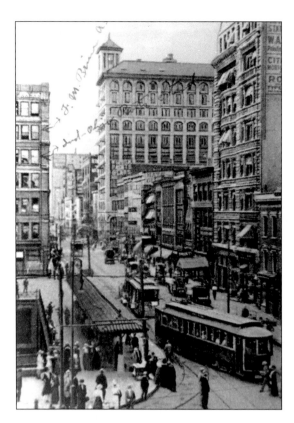

Once upon a time CSR streetcars could travel southward on Main Street, as seen here at Fifth Street, *circa* 1910. An ornate waiting shelter at the lower left, the only such facility in Cincinnati, kept patrons dry in inclement weather under a tiled roof. (Courtesy of the Earl Clark collection.)

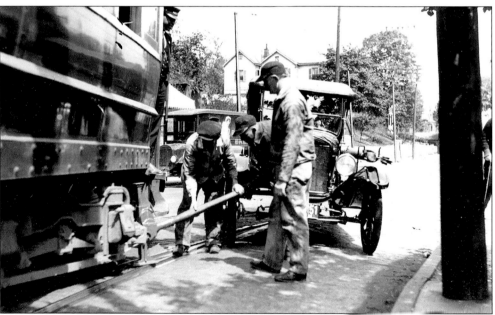

Workers used a lifting jack to move a derailed streetcar in 1920. The "Model T emergency wagon" was on call for such situations and carried spare parts and tools to repair distressed streetcars. (Courtesy of the Earl Clark collection.)

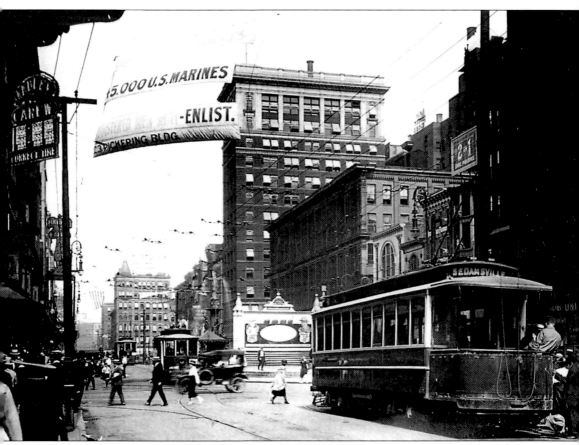

Sedamsville-bound passengers board car 1739 at Fifth and Vine in 1917. Patriotism ran high during World War I as evidenced by numerous banners urging enlistment in the Marines and Army. (Courtesy of the Fred Bauer collection.)

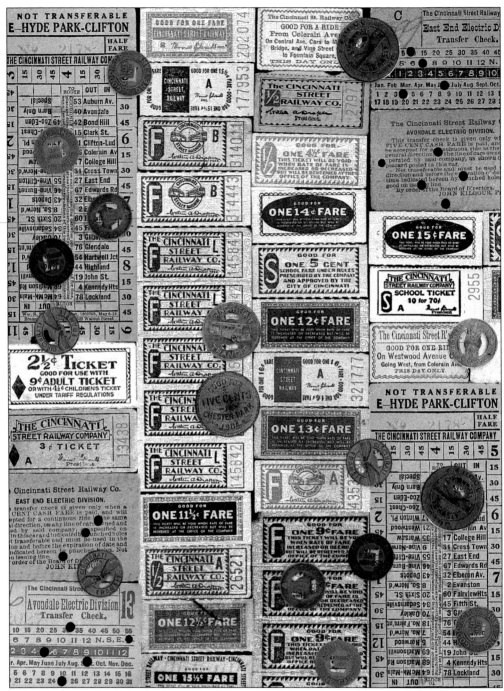

Throughout their terms of service the CSR streetcars accepted cash money for fare and also sold coin-like tokens and paper tickets to its passengers. Streetcar riders could also request paper transfers to connect with other cars of the system. Passes and tokens for streetcars and motor buses for both the CSR and the Covington Green Line are included here; the tokens contain oval holes to prevent people from using them as money. Seen here also is a 1904 token good for 5¢ of amusement at Chester Park. (Courtesy of the Alvin Wulfekuhl collection.)

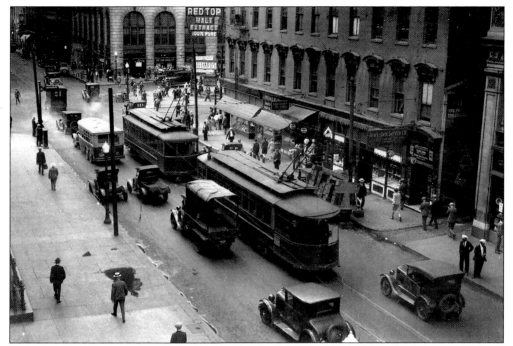

Streetcars and automobile traffic share Walnut Street near Fifth in 1925. The curved platform at the rear of the car allowed passengers to smoke their cigars outside without bothering the other riders. (Courtesy of the Earl Clark collection.)

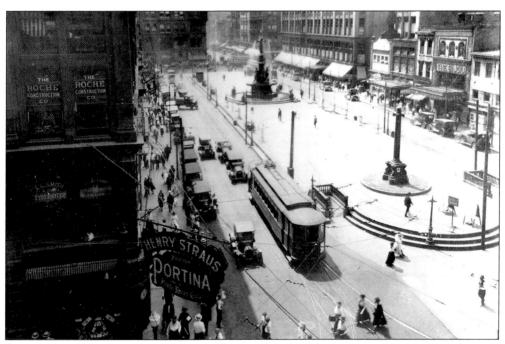

An eastbound streetcar passes Fountain Square *circa* 1925. Passengers riding in the streetcars would often look through the windows to watch the water splashing from the Tyler Davidson Fountain. (Courtesy of the Earl Clark collection.)

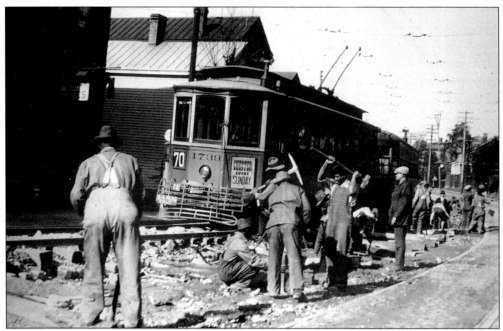

A work crew lays new track next to an existing one on Madison Road at Cohoon in O'Bryonville, *circa* 1925. Car 1739, pulling a trailer car, is passing by on wobbly-looking temporary track next to the workers, on its way to the Hyde Park car barn. A sign on the car reminds folks to visit the popular Chester Park on Sundays. (Courtesy of the Earl Clark collection.)

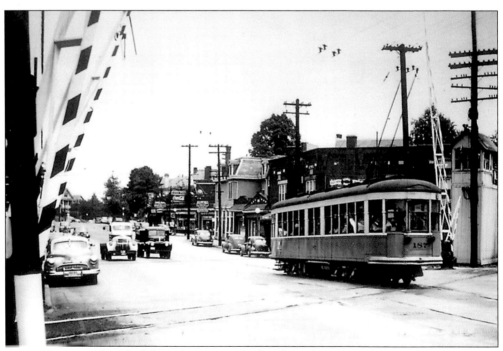

Car 187 crosses the Norfolk and Western Railroad tracks on Madison Road approaching Edwards Road, on its way to Oakley. (Courtesy of the Russ Schram collection.)

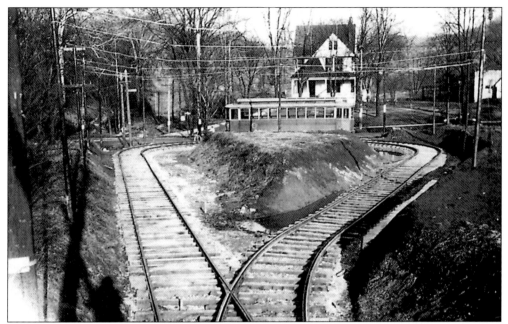

A streetcar lays over on the "Fernbank Loop" at Gracely Drive and Birch Lane in 1931. This loop was built after the old Cincinnati, Lawrenceburg, and Aurora interurban tracks to Aurora were abandoned and the CSR took over the shortened route. (Courtesy of the Fred Bauer collection.)

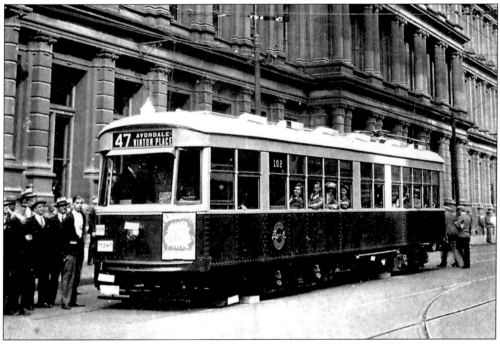

This brand new streetcar is proudly displayed in front of the old Post Office on Government Square in 1928. It was part of a group of 100 new cars built for the CSR by the Cincinnati Car Company in Winton Place. (Courtesy of the Fred Bauer collection.)

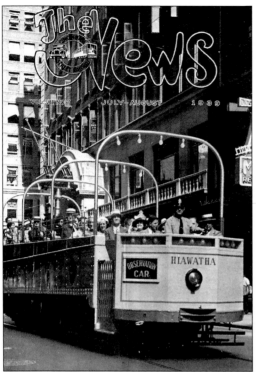

The old *Hiawatha* name was recycled in 1939 for one of the CSR's two new open-air observation cars, equipped with raised seating toward the rear. For only 25¢, the two-hour ride on these unique cars allowed passengers an unparalleled view of the city during the warmer months of the year. Here the *Hiawatha* is on Fourth Street just past the famous Mills Restaurant. (Courtesy of the Fred Bauer collection.)

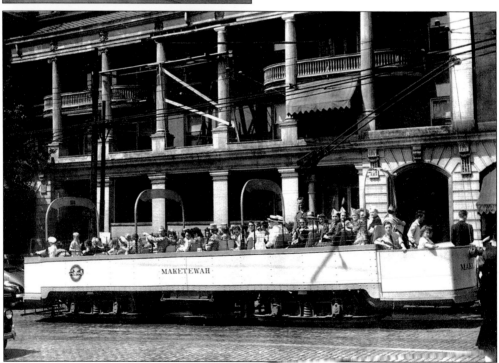

Passengers enjoyed feeling the breeze on their faces while riding on the *Maketewah* on West Eighth at Elberon in Price Hill in the early 1940s. The apartment building, with its columns and curved balconies, still stands today. (Courtesy of the Fred Bauer collection.)

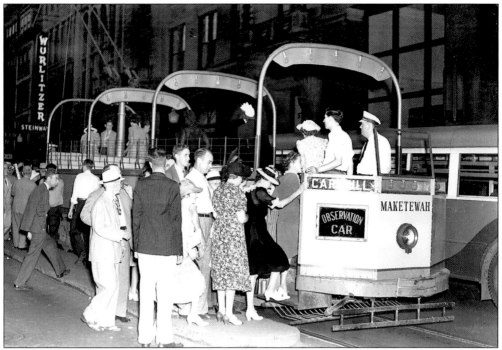

Passengers board the *Maketewah* on Fourth and Walnut to cool off and enjoy a nice August evening in 1942. These riders possibly also hope to temporarily forget about their boys fighting overseas. (Courtesy of the Dan Finfrock collection.)

Car 134 drops off a passenger at the loading platform on Harrison Avenue at Westwood Avenue in 1947. (Courtesy of the Cliff Scholes collection.)

Below the hill on Clifton Avenue, car 2438 makes its way down from Clifton, passing Klotter Street. The photograph was taken in 1948 from a point very close to where the popular Bellevue House, at the top of the Bellevue Incline, had been located so many years before. (Courtesy of the Cliff Scholes collection.)

Ladies board car 2411 on East Fifth Street downtown in 1948 in front of the Wesley Chapel, which later was torn down to make way for the new Proctor and Gamble office buildings. The Trailways bus depot is seen in the background. (Courtesy of the Fred Bauer collection.)

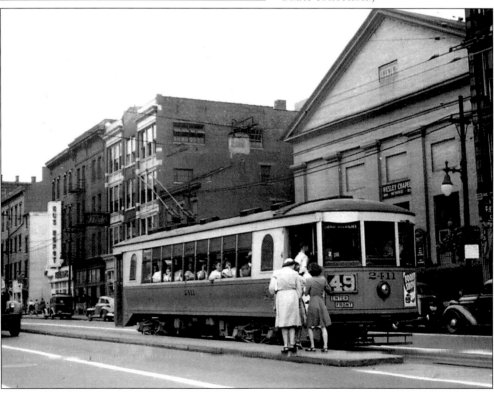

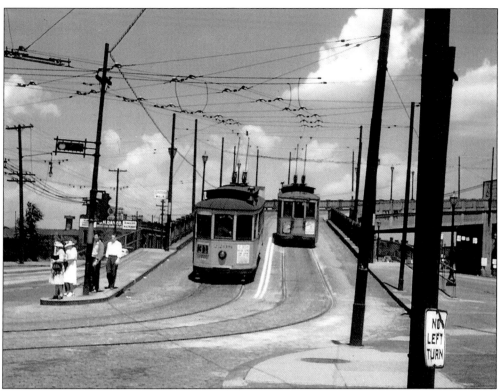

Two streetcars on the heavily traveled Crosstown Line negotiate the Brighton ramp over Central Parkway at Colerain Avenue in 1947. (Courtesy of the Russ Schram collection.)

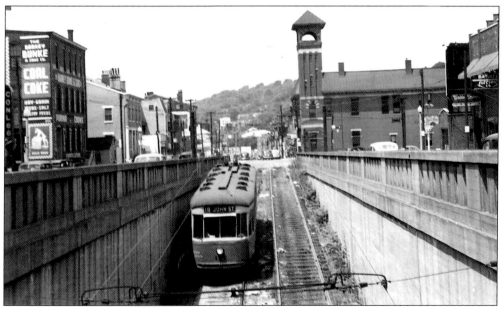

Car 127 makes its way into the western entrance of the lower deck of the Western Hills Viaduct in 1950. The firehouse at Harrison and Beekman stood for many decades as a familiar city landmark. (Courtesy of the Cliff Scholes collection.)

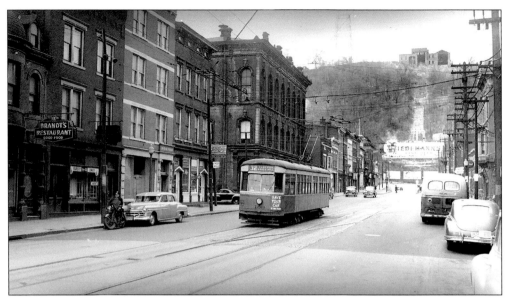

Abandoned since July 1943, the ruins of the Price Hill Incline station and path can be seen on the hill behind this intersection of Eighth and Depot Streets in 1950. The shuttle bus at the right replaced the incline and carried the passengers to the top of the hill on local streets. (Courtesy of Tom McNamara, Alvin Wulfekuhl collection.)

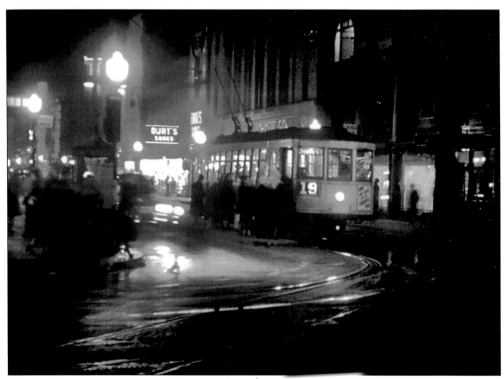

It's a brisk, winter evening in 1949 at Fifth and Vine in front of Rollman's and Woolworth's. Shoppers are anxious to board the warm streetcar and head home after visiting their favorite downtown department stores. (Courtesy of C.R. Scholes, photographer, Earl Clark collection.)

Six

STREET RAILWAY GOES ART DECO

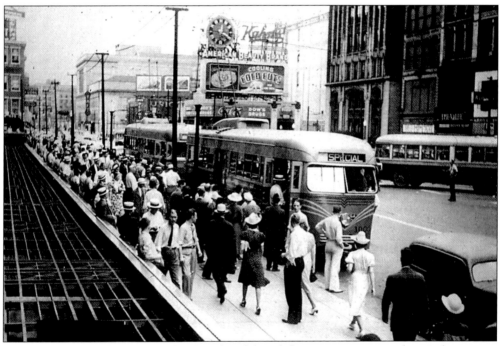

Times changed. New art styles developed and found their way into many design elements in the 1930s. The look of the orange streetcars in Cincinnati remained mostly the same since their introduction, but in the late 1930s the "modernist movement" (known today as "art deco") was designed into a new fleet of CSR streetcars. This "PCC" car is on display to the public at Government Square in 1939. This car, first painted orange and later yellow, was a short-lived attempt to update the system with a modern, streamlined car. For the first time a Cincinnati streetcar delivered good ventilation, smooth and rapid acceleration and braking, and a remarkably comfortable and quiet ride. (Courtesy of the Earl Clark collection.)

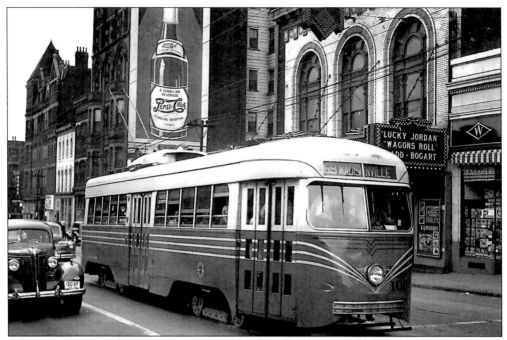

A new PCC car cruises on McMillan Street, passing the Orpheum Theater in Walnut Hills in 1942. The PCC car was the result of a design initiated by the "President's Conference Committee," a group of street railway executives who sought an entirely new concept in rail transportation. (Courtesy of the Fred Bauer collection.)

Another modern streetcar was the turquoise-colored Brilliner in 1939, seen here on Mitchell Avenue. (Courtesy of the Fred Bauer collection.)

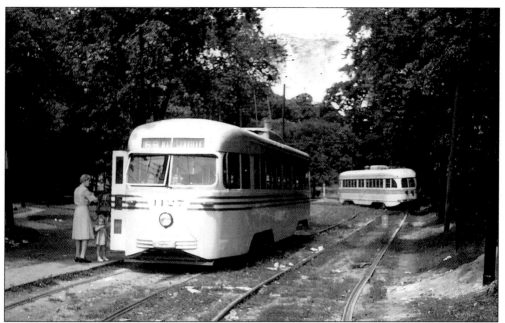

It is 1947, and a lady and her granddaughter are about to board a car at the end of the Madisonville line at Kenwood Road and Madison. By 1947 PCC car 1000 had been painted yellow with green stripes and renumbered 1127. (Courtesy of the Russ Schram collection.)

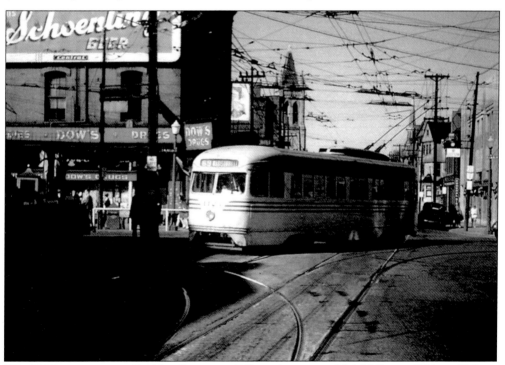

This PCC car navigates Peebles Corner at Gilbert Avenue and McMillan in Walnut Hills in 1947. Many Cincinnatians fondly recall Schoenling beer and Dow's drugstores. (Courtesy of the Fred Bauer collection.)

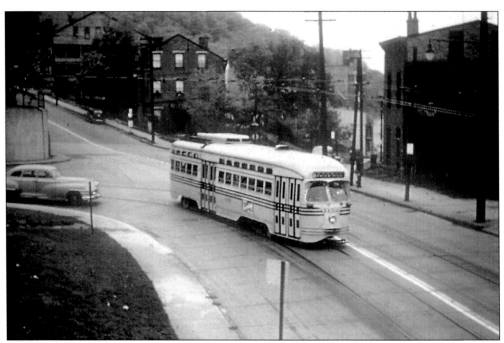

A new series of PCC cars was introduced in 1947, featuring "standee windows" installed above the existing windows. This car rounds the bend at Glenway and Wilder in Lower Price Hill. (Courtesy of the Earl Clark collection.)

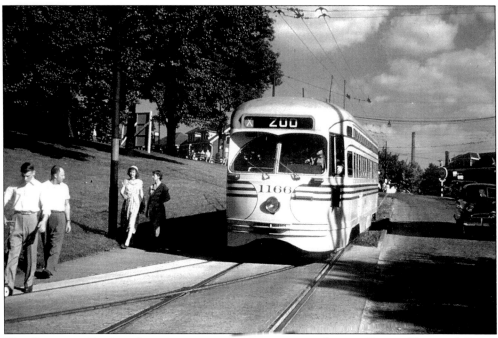

The Cincinnati Zoo has always been a popular destination and was well served by two different streetcar lines. Car 1166 rolls down Vine Street, just north of Erkenbrecher in 1948. (Courtesy of the Fred Bauer collection.)

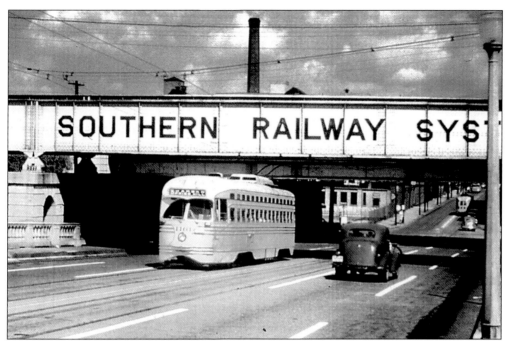

A later model PCC car 1161 passes beneath the Southern Railway Bridge on the Eighth Street Viaduct. The viaduct has been modified somewhat since this photograph was taken in 1948. (Courtesy of C.R. Scholes, photographer, and the Fred Bauer collection.)

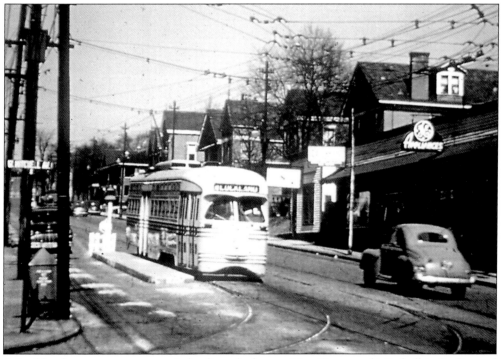

A Lockland car pauses at an empty loading platform at Vine Street and Mitchell in St. Bernard in 1948. (Courtesy of the Fred Bauer collection.)

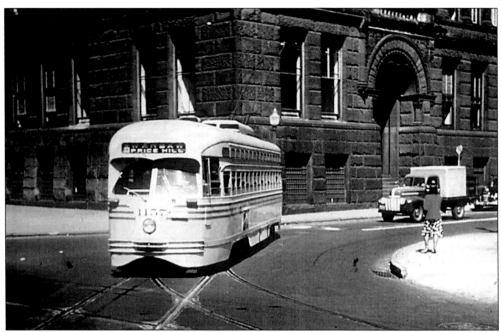

City Hall looms in the background as car 1157 travels Eighth Street and crosses Central Avenue downtown on its way to Price Hill in 1948. (Courtesy of the Earl Clark collection.)

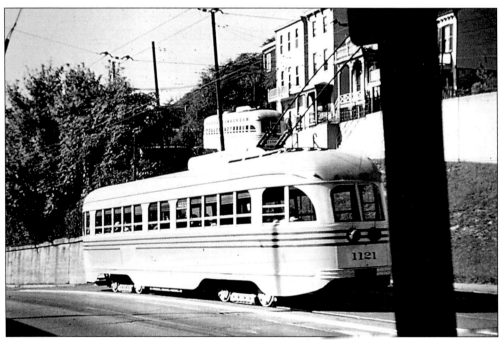

A 1940 model PCC car (lacking standee windows) goes downhill on Glenway Avenue, while a brand new PCC car travels uphill on Wilder Avenue to Price Hill in 1947. (Courtesy of the Earl Clark collection.)

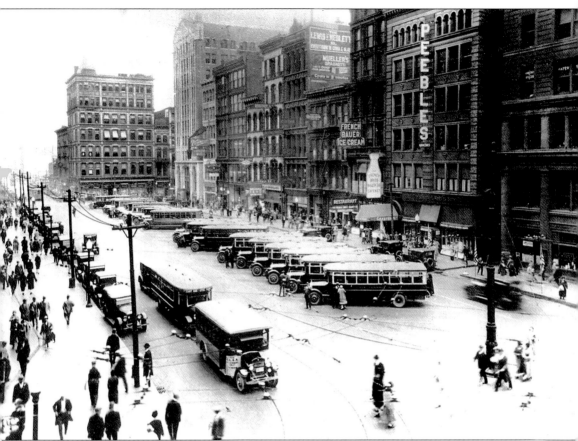

Independently-operated motor coach buses started running in Cincinnati early in the 20th century, competing with the CSR streetcar service. Mergers brought the different bus lines together under the CSR system in the 1920s. Since then, regulated motor coach bus service shared the streets with automobiles and streetcars, until the streetcars were fazed out in 1951. Here, a line of city buses waits for passengers on Government Square in the late 1920s. The bus in the left foreground took passengers to the Cincinnati, Lawrenceburg, and Aurora interurban at Anderson Ferry. (Courtesy of the Fred Bauer collection.)

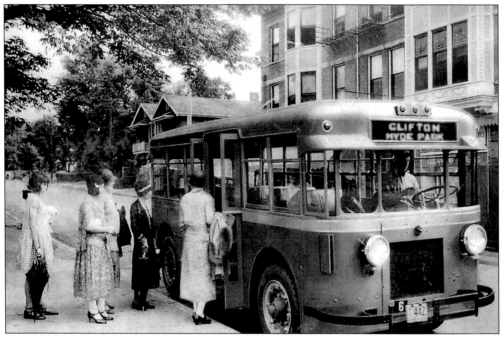

Several ladies board a Twin Coach bus on Edwards Road near Hyde Park Square in 1929. (Courtesy of the Phil Lind collection.)

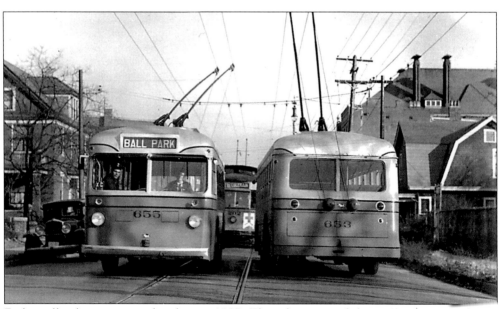

Early trolley buses pass each other in 1937. The advantage of the trolley bus was that it relied on the overhead wires to power its motor, and its rubber tires enabled it to maneuver around obstructions while giving passengers a more comfortable ride. (Courtesy of the Fred Bauer collection.)

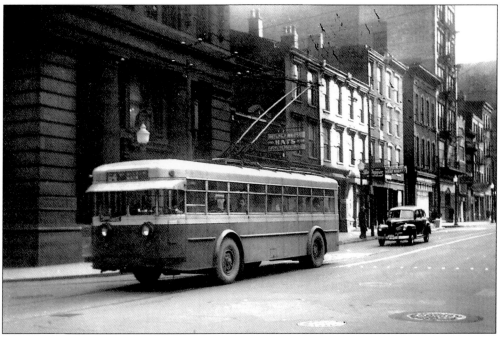

A Twin Coach trolley bus rolls up Main Street at Ninth in 1939. (Courtesy of the Russ Schram collection.)

Motor coaches pick up and drop off their fares on Government Square in prewar Cincinnati in 1940. (Courtesy of the Fred Bauer collection.)

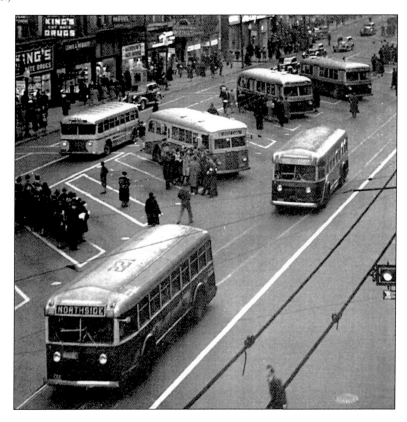

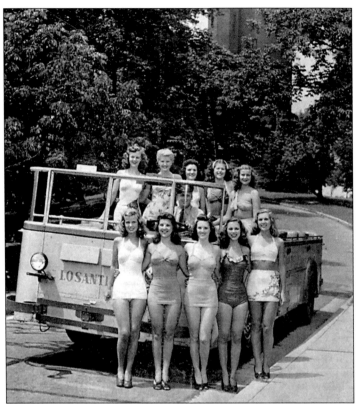

A flock of bathing beauties pose with the *Losantiville* open-air sightseeing bus during the summer in 1946. This bus was a gasoline-powered companion to the *Columbia* sightseeing bus. (Courtesy of the Fred Bauer collection.)

Trolley coach 1228 heads south on Spring Grove Avenue toward Harrison Avenue in 1950. The PCC car in the distance has just emerged from the lower deck of the Western Hills Viaduct. (Courtesy of C.R. Scholes, photographer, and the Fred Bauer collection.)

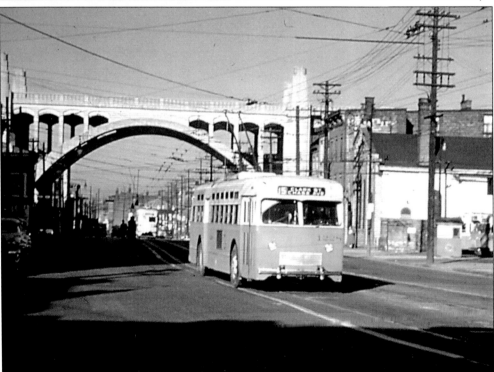

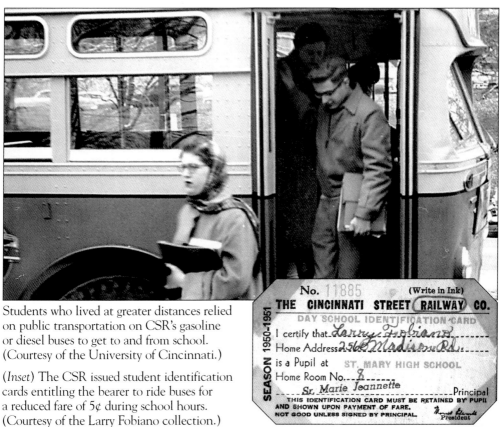

Students who lived at greater distances relied on public transportation on CSR's gasoline or diesel buses to get to and from school. (Courtesy of the University of Cincinnati.)

(*Inset*) The CSR issued student identification cards entitling the bearer to ride buses for a reduced fare of 5¢ during school hours. (Courtesy of the Larry Fobiano collection.)

No. 11885 (Write in Ink)
THE CINCINNATI STREET RAILWAY CO.
DAY SCHOOL IDENTIFICATION CARD
I certify that *Larry Fobiano*
Home Address *2566 Madison Rd.*
is a Pupil at ST. MARY HIGH SCHOOL
Home Room No. *8*
 Sr. Marie JeannettePrincipal
THIS IDENTIFICATION CARD MUST BE RETAINED BY PUPIL
AND SHOWN UPON PAYMENT OF FARE.
NOT GOOD UNLESS SIGNED BY PRINCIPAL. President

SEASON 1950-1951

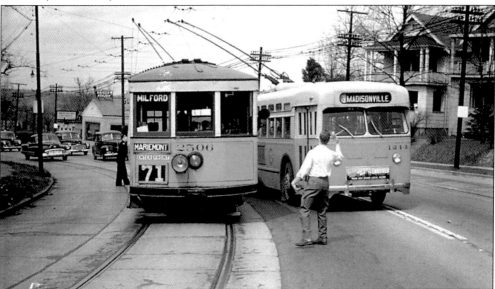

At the S-Curve on Erie Avenue, a trolley bus passes an old-style streetcar on a fantrip in 1950. To allow the bus to pass, the streetcar had to stop and have its trolley poles removed from the overhead wires, as photographer Cliff Scholes directs traffic. A Kaiser Frazer dealership can be seen in the background. (Courtesy of C.R. Scholes, photographer, and the Fred Bauer collection.)

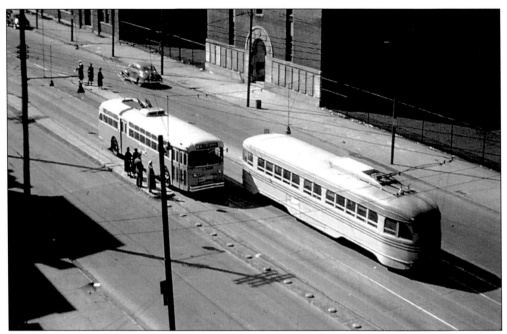

An orange trolley bus pulls away from a loading platform on Spring Grove Avenue. Meanwhile, a yellow PCC car glides to a stop near the Western Hills Viaduct in 1950. (Courtesy of C.R. Scholes, photographer, and the Fred Bauer collection.)

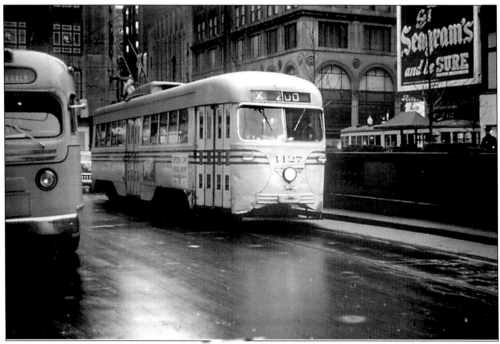

A chartered PCC car takes passengers on a special "fantrip" through downtown next to Fountain Square on April 22, 1951, just one week before the end of all streetcar service. (Courtesy of C.R. Scholes, photographer, and the Fred Bauer collection.)

Seven

WHERE THE GREEN TROLLEYS GO

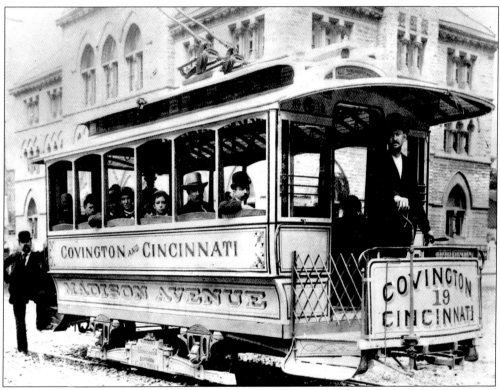

Across the river in Covington, electric street railway service began operation in 1890 under the Cincinnati, Newport, and Covington system, which formed during the previous horsecar years. Large panels on the sides of the cars in the various lines were painted certain colors, including white, red, blue, or yellow to differentiate the lines for the less-literate passengers. Green was substituted for yellow in 1877 on the Main Street Line, and the "Green Line" was born. Car 19 of the Green Line was the first electric car in service in Covington and the first to cross the Suspension Bridge into Cincinnati. (Courtesy of the Earl Clark collection.)

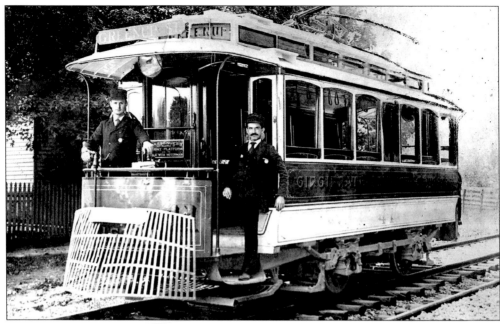

Car 41 was among the first of this type of electric streetcar to appear on Covington's newly-built Greenup line. Motorman William Brocterick at left stands ready at the controls in car 41 in 1893, and Conductor C. Forsett strikes a dignified pose. (Courtesy of the Kenton County Library.)

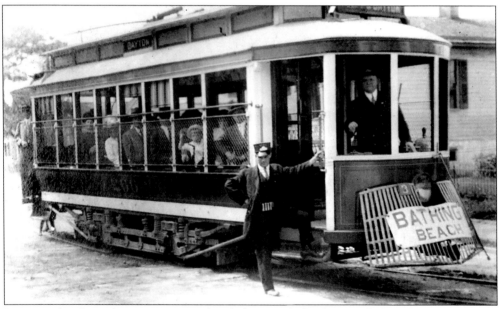

By 1912 the City of Covington mandated that vestibules be installed in the fronts of the streetcars so the motorman's area could be heated during winter months. In the summertime the front windows were removed, as they have been in Car 266 that took passengers to the bathing beaches in Dayton, Kentucky. A major difference between the Cincinnati streetcars and the Green Line is the screened-over windows installed for the safety of the passengers. (Courtesy of the Alvin Wulfekuhl collection.)

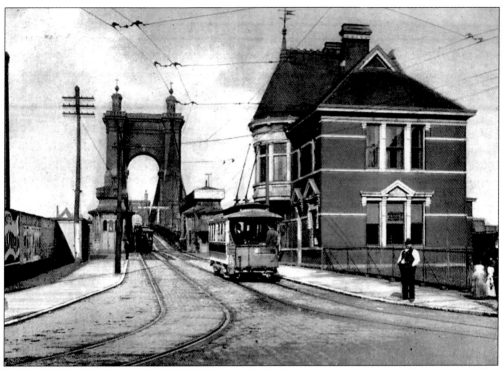

A Green Line car approaches the Suspension Bridge to cross the river into Cincinnati in this postcard from 1895. The building on the right was the headquarters for the Covington and Cincinnati Bridge Company that operated the bridge. (Courtesy of the Fred Bauer collection.)

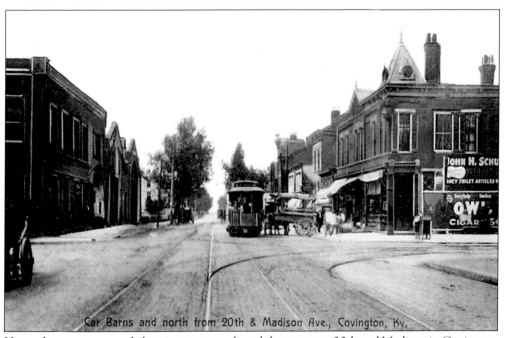

Car Barns and north from 20th & Madison Ave., Covington, Ky.

Horse-drawn wagons and electric streetcars shared the streets at 20th and Madison in Covington in 1903. (Courtesy of the Fred Bauer collection.)

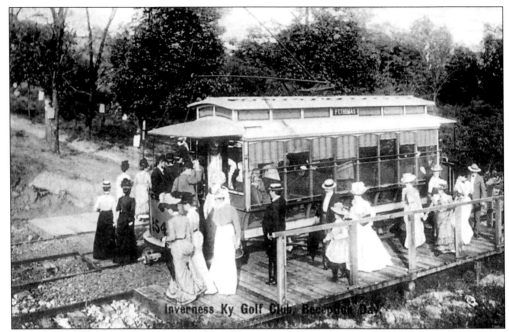

Just like in Cincinnati, open-air summer cars carried passengers to points of interest around Northern Kentucky, such as a golf outing at Inverness in Fort Thomas in 1905. (Courtesy of the Fred Bauer collection.)

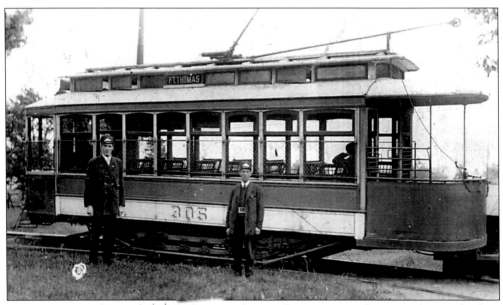

Green Line cars often included platforms on the rear for passengers who wanted to smoke their pipes and cigars without bothering the non-smokers, such as this one *circa* 1905. (Courtesy of the Fred Bauer collection.)

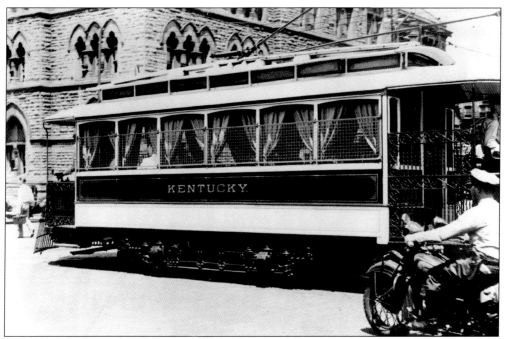

This car, the *Kentucky*, was built in 1892 and refurbished in 1911 to serve as a business car for Green Line President James C. Ernst. The *Kentucky* was also available for private charters as a parlor car, featuring curtains, carpeting, wicker furniture, side tables, and ornate lighting fixtures. (Courtesy of the Kenton County Public Library.)

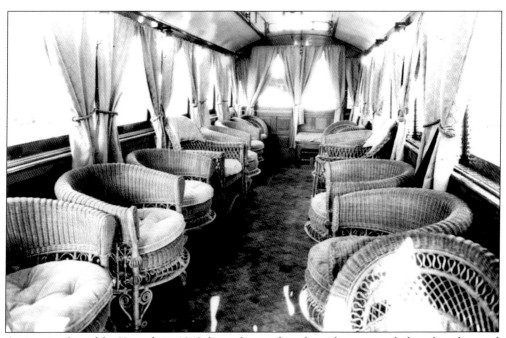

An interior shot of the *Kentucky* in 1942 shows the comforts that riders expected when they chartered their private parlor car. Passengers taking typical streetcars would have had to sit on hard, bench-like seats, but in the *Kentucky*, they rode in style. (Courtesy of the Dan Finfrock collection.)

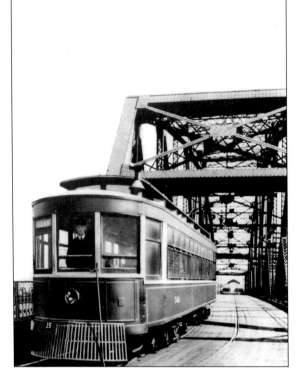

A brand new Green Line car, 500 crosses the Licking River Bridge into Covington from Newport, *circa* 1920. (Courtesy of the Earl Clark collection.)

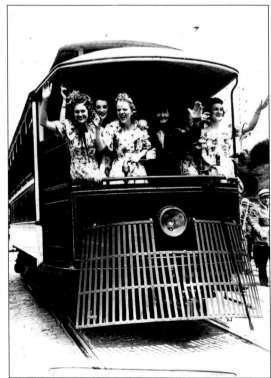

Ludlow celebrated its 75th anniversary in 1939, and the old favorite *Kentucky* parlor car led the parade. Excited young women riding up front waved to the crowds as the 40-plus year old streetcar rolled by. (Courtesy of the Earl Clark collection.)

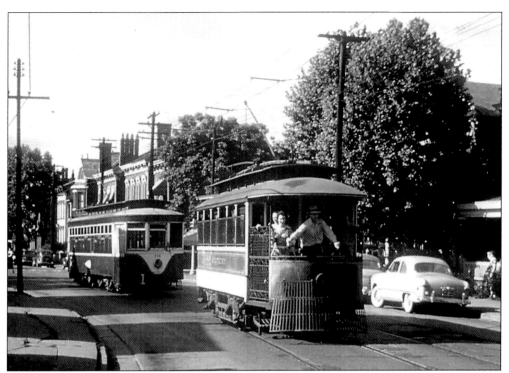

The *Kentucky* remained available for private fantrips through the later years. A Green Line car patiently follows the *Kentucky* up Greenup Street between 15th and 16th on July 2, 1950, the last day of streetcar service in the state of Kentucky. (Courtesy of C.R. Scholes, photographer, and the Fred Bauer collection.)

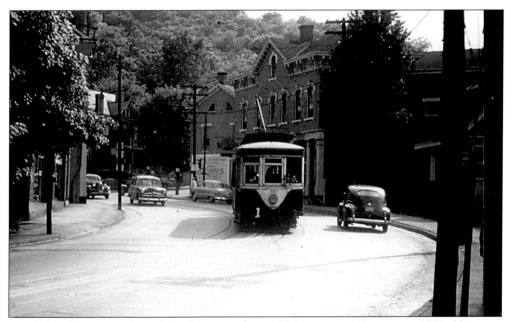

Car 527 makes its way down Pike Street just beyond Montague in Covington, 1950. (Courtesy of C.R. Scholes, photographer, and the Fred Bauer collection.)

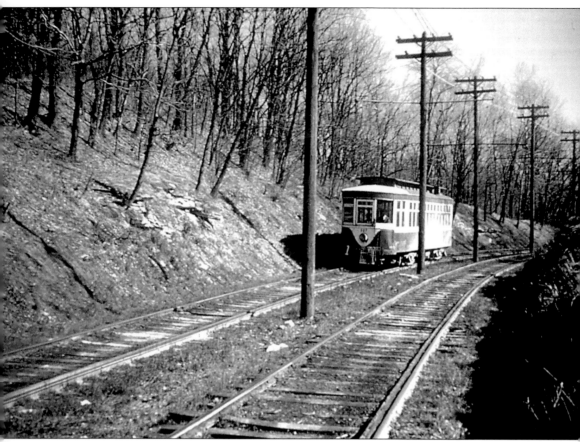

Tranquil scenes, such as this one in Park Hills *circa* late 1940s, often greeted Green Line passengers in Northern Kentucky. (Courtesy of C.R. Scholes, photographer, and the Fred Bauer collection.)

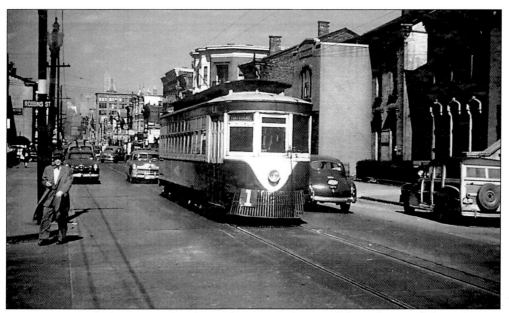

Green Line cars had to contend with a wide variety of automobile traffic on Madison Avenue in 1947, such as the Woody station wagon, the Hudson, and the Studebaker, all gone now from Covington streets. (Courtesy of C.R. Scholes, photographer, and the Fred Bauer collection.)

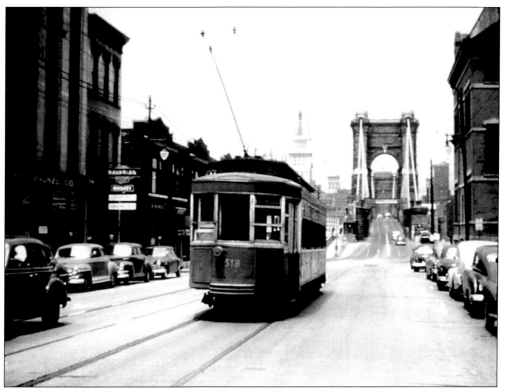

In 1948 car 518 is about to leave Court Street in Covington for its trip across the Suspension Bridge to the Dixie Terminal in Cincinnati. (Courtesy of the Fred Bauer collection.)

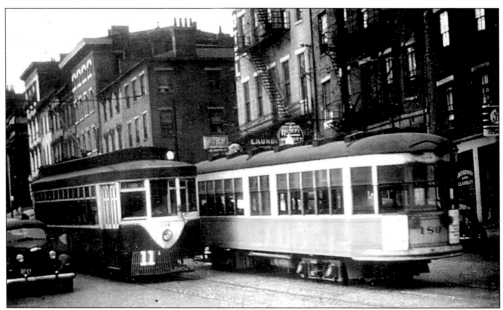

North meets South as a Cincinnati Street Railway car passes a Fort Thomas Green Line car on Broadway at Pearl Street in downtown Cincinnati in 1946. (Courtesy of the Fred Bauer collection.)

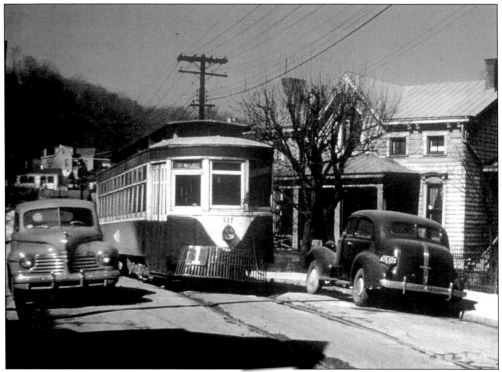

Green Line cars often operated on narrow suburban streets. Car 521 threads its way along Montague Street in Covington in 1948. (Courtesy of C.R. Scholes, photographer, and the Fred Bauer collection.)

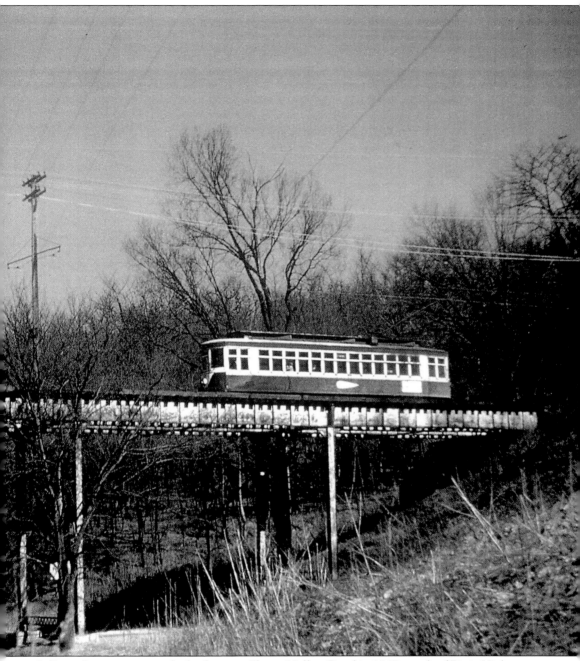

A Green Line car crosses the bridge over Sleepy Hollow Road in 1947, north of Dixie Highway in the scenic byways of Fort Wright. This bridge is gone now, lost to the growth of suburbs in Northern Kentucky. (Courtesy of C.R. Scholes, photographer, and the Fred Bauer collection.)

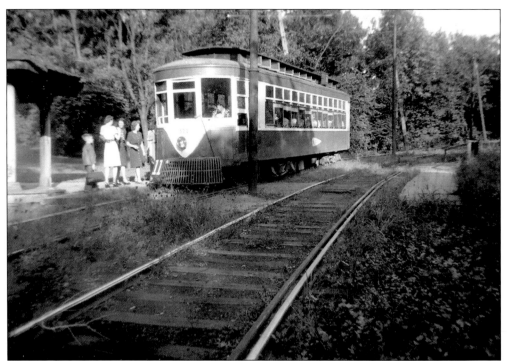

Passengers board car 522 on Pleasant Hill Street in Fort Thomas in 1945. (Courtesy of C.R. Scholes, photographer.)

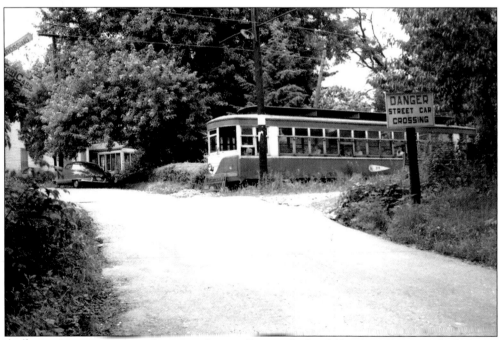

A Green Line car is hazardous to other traffic on Orchard Road in Fort Mitchell, 1949. (Courtesy of C.R. Scholes, photographer.)

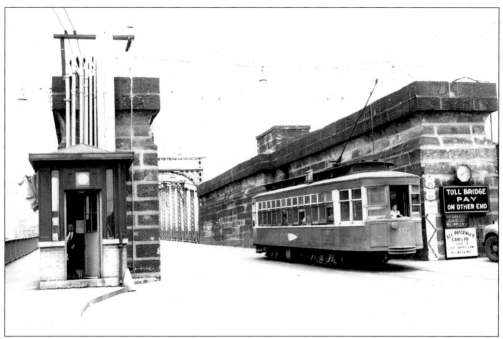

As late as 1950, a solitary bridge employee's one job was to collect 10¢ tolls from passing automobiles and 2¢ from pedestrians crossing the Suspension Bridge. (Courtesy of C.R. Scholes, photographer.)

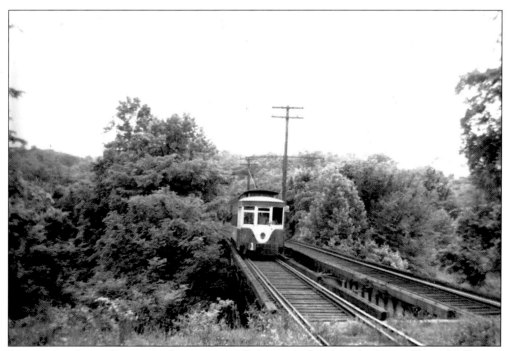

In a seemingly totally remote location, car 516 crosses the short bridge at Sleepy Hollow in 1950. (Courtesy of C.R. Scholes, photographer.)

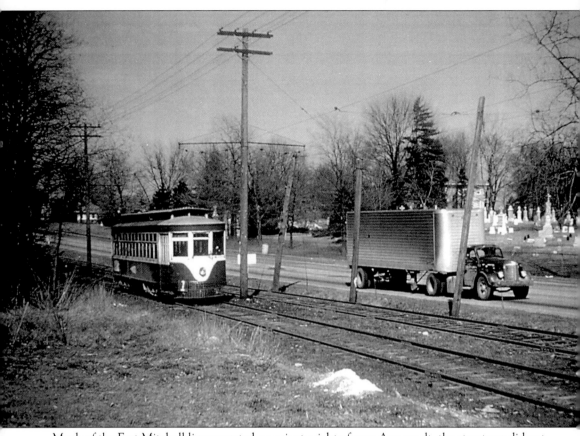

Much of the Fort Mitchell line operated on private right of way. As a result, the streetcars did not have to contend with delays caused by street traffic. Here, car 518 hums along Dixie Highway just across from St. Mary's Cemetery circa 1950. (Courtesy of C.R. Scholes, photographer, and the Fred Bauer collection.)

Eight

THE MIGHTY ELECTRIC INTERURBAN

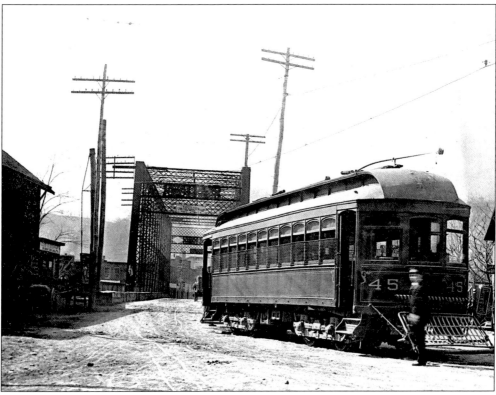

Electricity enabled streetcars to move citizens around town, but streetcar lines ran only within city limits. To travel to other towns around Cincinnati and the entire Midwest, folks rode the electrically-powered interurban railroad lines. Riders on the interurbans could visit nearly any city they wished, which was much more difficult when horses and carriages were the only transportation method they had. Those living in Southeastern Indiana who wanted to visit Cincinnati would have ridden the Cincinnati, Lawrenceburg, and Aurora interurban line, which terminated in Aurora near the George Street Bridge, *circa* 1905. (Courtesy of the Earl Clark collection.)

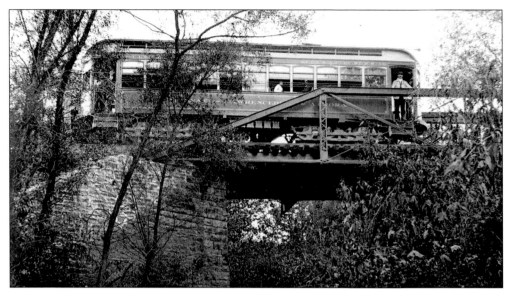

After boarding at the Aurora station, interurban passengers rode the CL&A car across Wilson Creek in Lawrenceburg, *circa* 1902. The bridge, creek, and tracks are all gone now, as all of Southeastern Indiana has undergone major suburban development over the past century. (Courtesy of the Earl Clark collection.)

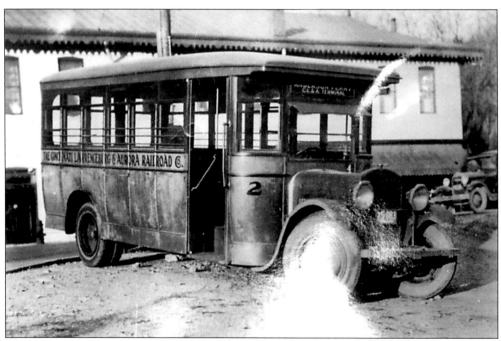

The CL&A line went only as far as Anderson Ferry in Delhi and dropped off the passengers at the interurban station next to the river. They then had to board CSR streetcar 34 to take them to Fourth and Vine Street in Cincinnati. Travel was slow since the streetcar had to stop numerous times along the way. In the later 1920s the CL&A instituted express bus service from the Anderson Ferry station into downtown. By 1930 the interurban was out of business. (Courtesy of the Earl Clark collection.)

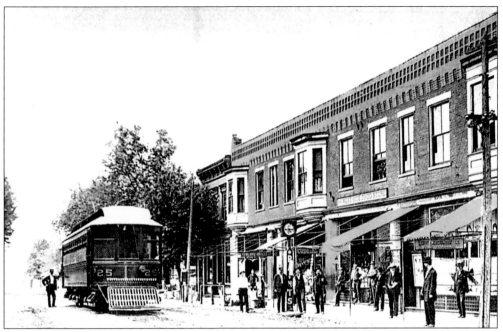

A branch of the CL&A line followed Kilby Road through Whitewater Township and ended at Harrison in 1903. A photographer would often attract quite a crowd of curious locals so early in the century. (Courtesy of the Earl Clark collection.)

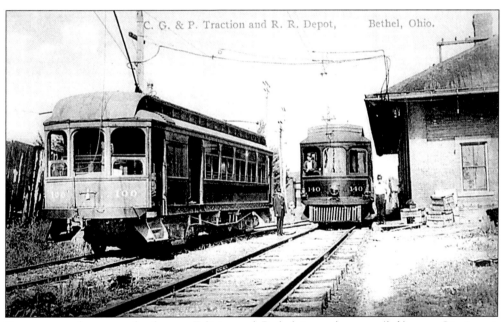

Passengers make a transfer from a Felicity and Bethel interurban car (left) to a Cincinnati, Georgetown, and Portsmouth car (right) in Bethel, Ohio, *circa* 1905. The CG&P ran from Columbia in the eastern part of the city and lasted 64 years. (Courtesy of the Earl Clark collection.)

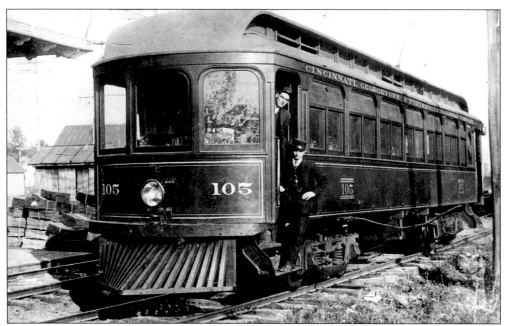

CG&P car 105 stands next to the Bethel Station, *circa* 1903. Motorman Connie C. Baldwin stands inside the vestibule, and Conductor Leonard Hauck stands on the steps below. The CG&P was in direct competition with the Interurban Railway and Terminal interurban, which also served Bethel during the same years. (Courtesy of the Earl Clark collection.)

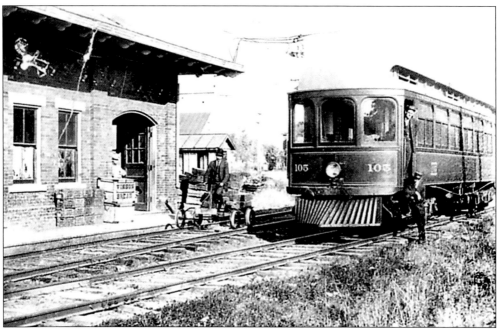

The camera has pulled back from the scene in the previous photograph to show more of the CG&P station and tracks, revealing a railroad employee riding a track inspection car. On the station platform can be seen two crates of bread from the Vinson Bakery in Bethel, destined for points along the line. (Courtesy of the Earl Clark collection.)

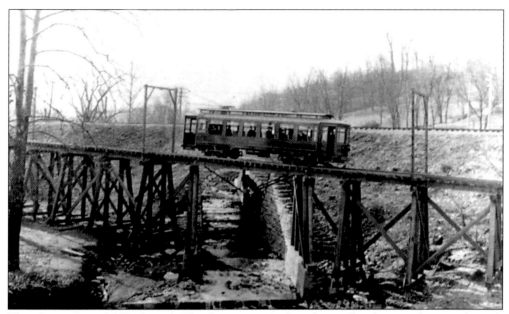

The Cincinnati, Milford, and Blanchester interurban line offered scenic routes through Cincinnati, such as this one at Terrace Park in 1905. The CM&B started operation in 1903 and offered service from Madisonville through Fairfax, Mariemont, and Indian Hill, all the way out to Milford. By 1926 the interurban was out of business, except for the portion from Milford to downtown Cincinnati. (Courtesy of the Earl Clark collection.)

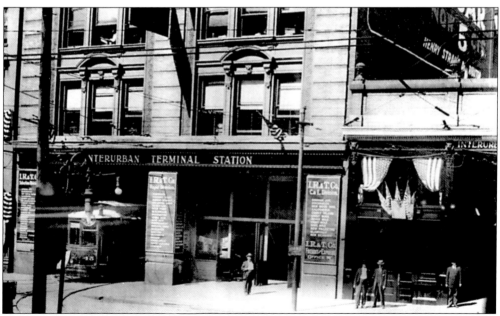

In order to visit family and friends in some areas east of Cincinnati, people took the Interurban Railway and Terminal line from 1903 to 1922. The IR&T station was conveniently located downtown on the west side of Sycamore Street, between Fourth and Fifth. The IR&T included three divisions: the *Suburban* to Bethel, *Rapid Railway* to Lebanon, and the *Cincinnati and Eastern* to New Richmond. (Courtesy of the Earl Clark collection.)

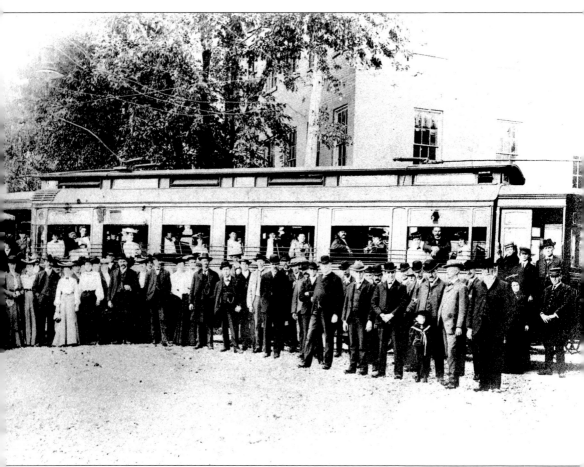

A crowd of excited local residents pose beside an IR&T car in Lebanon in 1903. This was the occasion of the interurban's first *Rapid Railway* run from Cincinnati to make the 33-mile trip to the little town. It took the car just two hours to travel to Lebanon, which represented a marked improvement over the much slower horse-drawn carriages the locals were used to. High speed rail service opened a whole new world for people living in the small towns in the Midwest. (Courtesy of the Earl Clark collection.)

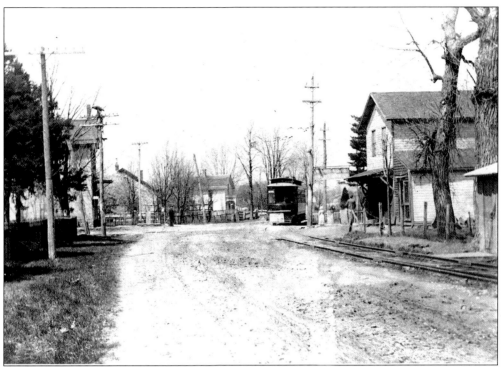

IR&T's Suburban Line made a 32-mile trip to Bethel. This included Stop 43, seen here at the northwest corner of Ohio Pike and Tobasco-Mt. Carmel Road, *circa* 1905. (Courtesy of the Earl Clark collection.)

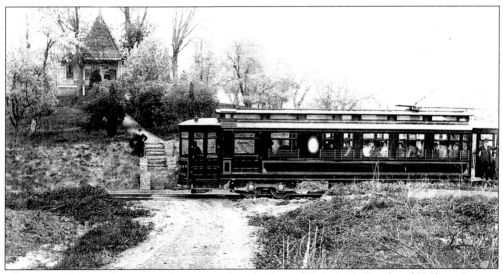

This IR&T Eastern division car has stopped at the foot of Eight Mile Road and Kellogg Avenue in1903. The man with the fuzzy beard standing on the steps is identified as the photographer, who rigged the camera to automatically take the picture while the car stopped in front of his house. The oval window on the car is for the lavatory, which had a sign on the door that read, "Passengers will please refrain from using toilet while car is standing at the Station." (Courtesy of the Earl Clark collection.)

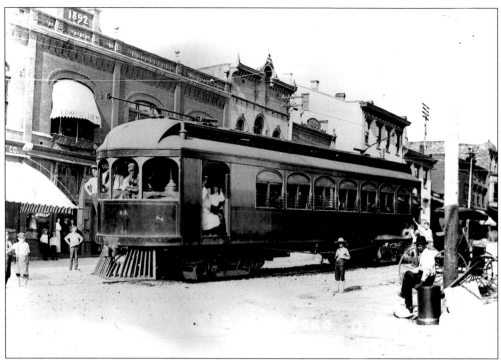

The Cincinnati and Columbus interurban served a 53-mile route from Norwood to Hillsboro. The line never made it to Cincinnati or Columbus in its years of operation from 1906–1920. C&C car 8 was the first one seen traveling through the streets of Hillsboro in 1906. (Courtesy of the Earl Clark collection.)

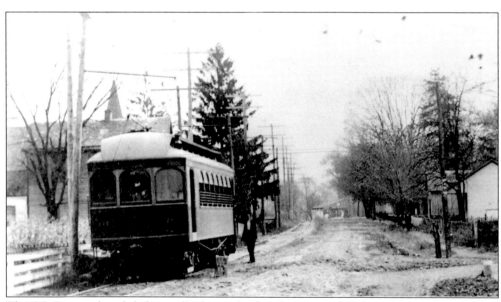

The C&C interurban failed partially due to the fact that it traveled through sparsely populated areas, never receiving enough suburban ridership to stay in business. This C&C car is inbound at Round Bottom Road and U.S. 50 in Perintown, Ohio, circa 1908. (Courtesy of the Earl Clark collection.)

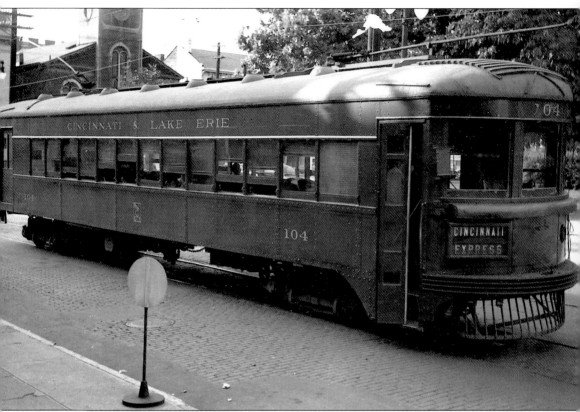

One of the Midwest's busiest and longest-lasting interurban railroads was the Cincinnati and Lake Erie. Passengers rode the C&LE line for over 40 years through the densely populated valleys between Cincinnati, Hamilton, and Dayton, and all the way to Detroit. The C&LE car 104 is parked at the Hamilton station on a pleasant afternoon in 1932. (Courtesy of the Earl Clark collection.)

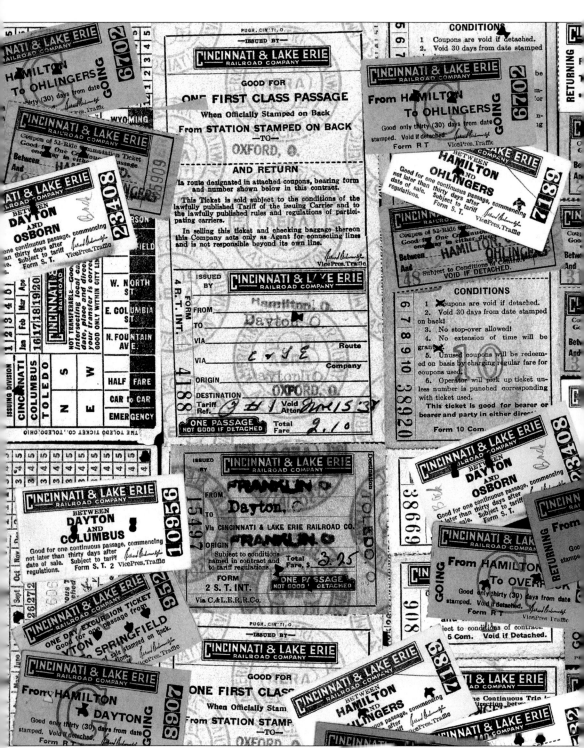

Success of the C&LE is partially due to the fact that this line served areas of Cincinnati with no other rail competition. Also, it was fast: C&LE Red Devil cars sped through the countryside, swiftly carrying passengers from tiny towns to major Midwestern cities. This collage of C&LE

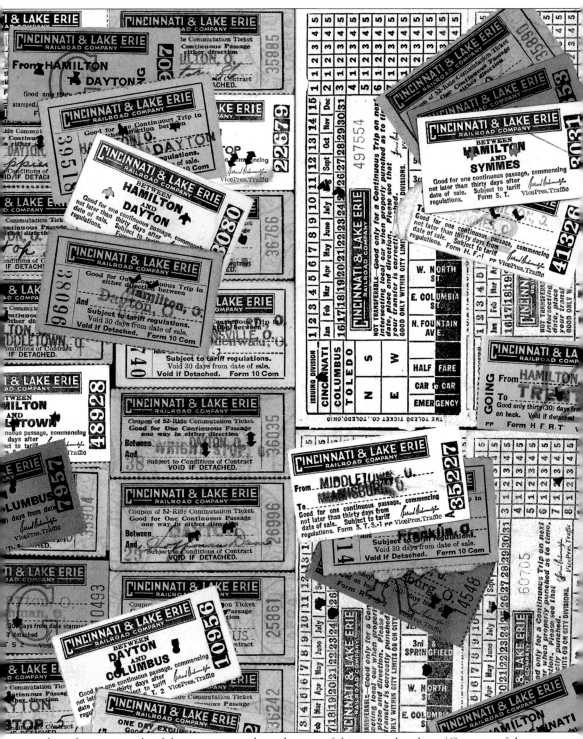

tickets shows a sample of the many stops along the way of this interurban line. (Courtesy of the Cincinnati Chapter NRHS.)

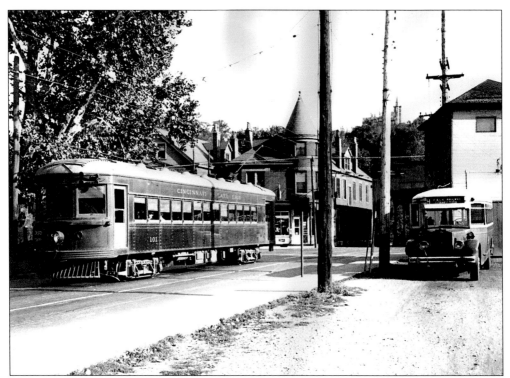

A C&LE shuttle bus waits next to the Cumminsville station at Spring Grove and Crawford for passengers to dismount from C&LE car 101 in 1936. This bus carried C&LE passengers to and from Government Square because the interurban could not access the CSR tracks due to the difference in track gauge. (Courtesy of the Alvin Wulfekuhl collection.)

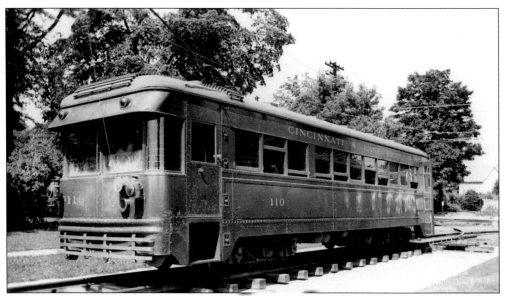

Passenger car 110 lays over on a wye in Mount Healthy in 1938, soon to depart for Dayton, Ohio. Car 110 faces its demise as a C&LE car because the company will go out of business in October of that year. (Courtesy of the Alvin Wulfekuhl collection.)

Nine

THIS IS CINCINNATI

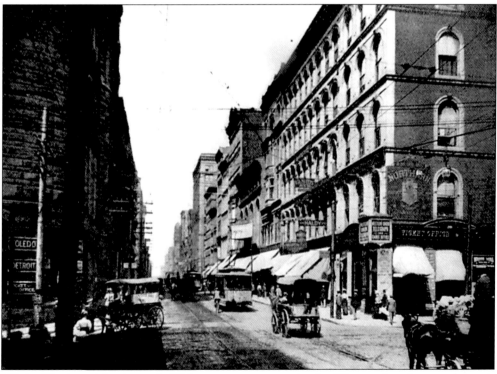

Life in Cincinnati in the early 20th century was completely different than how we know it today. This was a time when automobiles were just becoming part of the fabric of American society, when folks rode horses and carriages around the city—or simply walked wherever they needed to go. It was their way of life, the only way they knew. Before the turn of the 20th century, it was common to see horse-drawn carriages traveling downtown streets, as seen in this shot of Fourth Street, west from Vine, *circa* 1898. (Courtesy of the Earl Clark collection.)

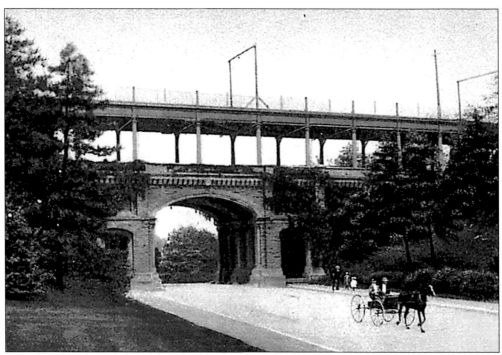

A horse pulling a carriage leaves Eden Park, *circa* 1900. Streetcars rode the top deck of the bridge over the arch at the entrance to the park. (Courtesy of Larry Fobiano collection.)

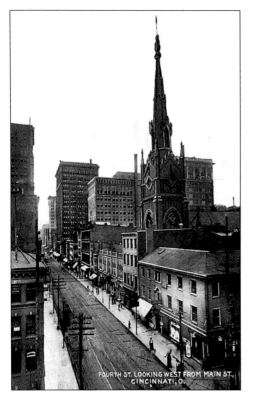

Fourth Street is empty of traffic, looking west from Main Street, *circa* 1905. The most prominent building on this street was the First Presbyterian Church, built in 1851. A 285-foot spire pointed skyward until the church was torn down in 1936 to make way for a parking lot to serve the ever-growing automobile population of the city. (Courtesy of the Sue Erhart collection.)

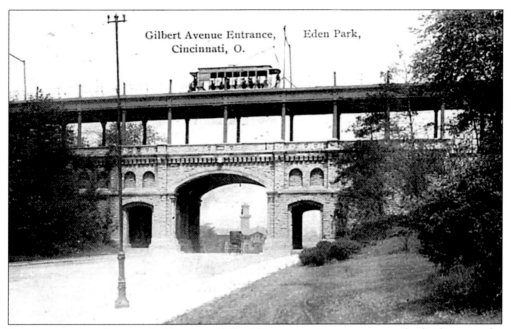

Gilbert Avenue Entrance, Eden Park,
Cincinnati, O.

Passengers enjoyed a remarkable vista while riding open-air streetcars on the bridge over the entrance to Eden Park, *circa* 1905. In 1947 estimates for needed bridge repairs proved too costly, so the Route 49 Zoo-Eden Park streetcars were rerouted to Gilbert Avenue, and the bridge was subsequently razed. (Courtesy of the Larry Fobiano collection.)

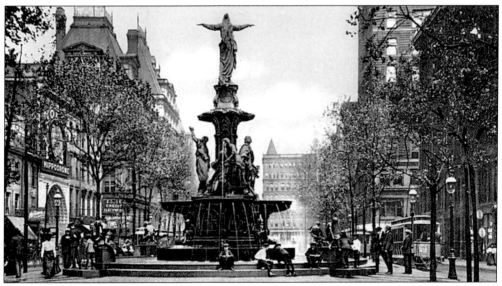

The Tyler Davidson Fountain has been the focal point of Cincinnati since the fountain was installed in 1877 and moved to its present location at Fifth and Vine in 1970. This was the core of the Queen City's civic, social, and commercial life; it was, and continues to be, a central place to bring Cincinnatians together. Celebrations and public appeals have occurred at Fountain Square, and the local population continues to enjoy public displays by artists, florists, civic groups, musicians, and countless other entertainment venues. (Courtesy of the Fred Bauer collection.)

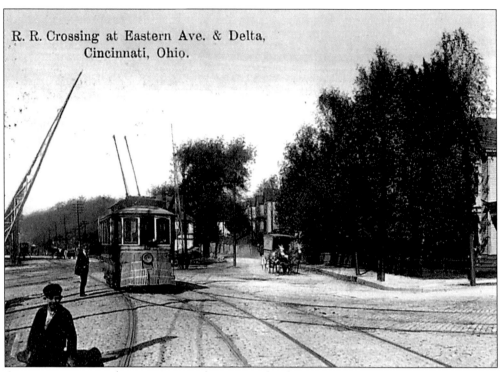

A streetcar pauses at the intersection of Eastern and Delta, *circa* 1905. A Pennsylvania and Ohio Railroad bridge now dominates these crossroads. (Courtesy of the Fred Bauer collection.)

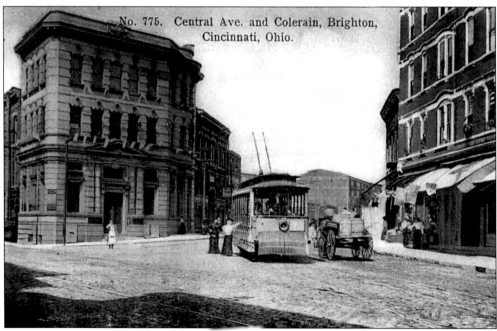

The once busy corner of Central Avenue and Colerain in Brighton no longer resembles this simple scene *circa* 1905. The bank building on the left still stands. (Courtesy of the Fred Bauer collection.)

Horse-drawn carriages dominate Fourth Street in this scene from 1905, showing the Queen City in a much less hectic time. (Courtesy of the Dan Finfrock collection.)

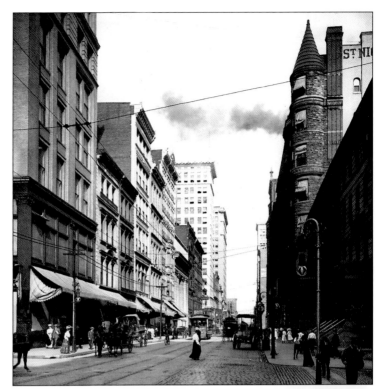

What a serene time it was in 1913 as horse-drawn wagons clatter eastward on empty Fifth Street. For just a moment, the wagons find no competition from streetcars or the newfangled horseless carriage. The Mount Adams Incline stands prominently in the background. (Courtesy of the Alvin Wulfkuhle collection.)

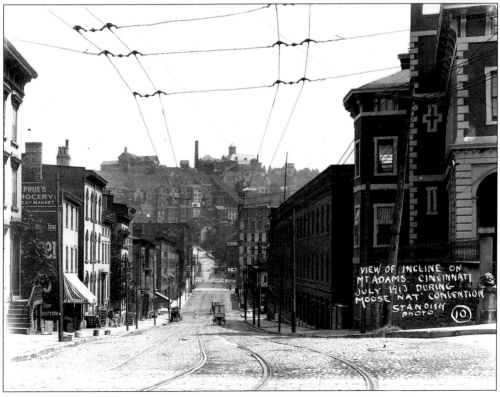

Parking spaces were plentiful for the early automobile traffic on Sixth Street *circa* 1918. Most of the

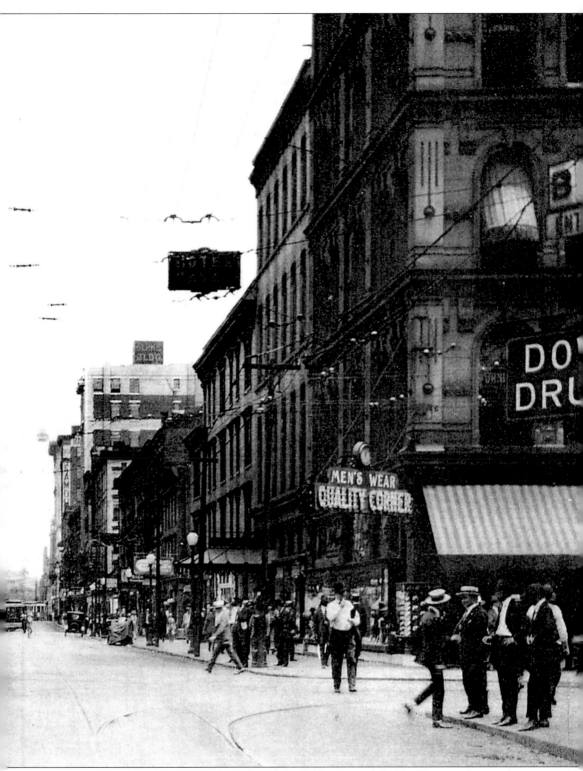

buildings seen here have long-since been demolished. (Courtesy of the Fred Bauer collection.)

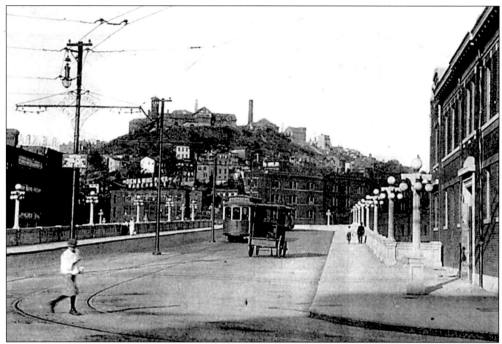

A streetcar passes a horse-drawn wagon on the Gilbert Avenue Viaduct, *circa* 1920. A street sign on the left advises that "Horse drawn vehicles will drive close to curb." Apparently the driver of this wagon didn't read the sign. (Courtesy of the Fred Bauer collection.)

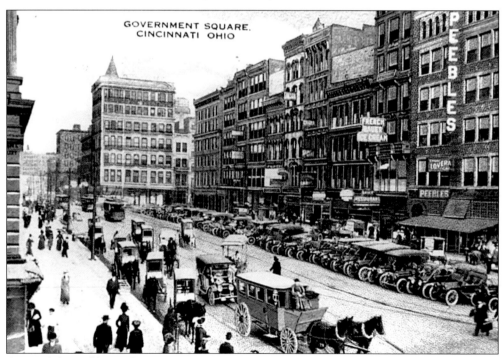

Automobiles and horse-drawn carriages congregate at Government Square, *circa* 1920. A decade later city buses would completely take over the block. (Courtesy of the Earl Clark collection.)

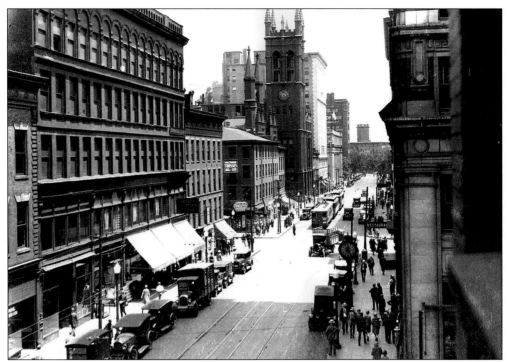

Horses and carriages gave way to technology through the years. Soon, streetcars and old-time automobiles and trucks filled Fourth Street in 1922. (Photograph by Ed Kuhr Sr., courtesy of the Dan Finfrock collection.)

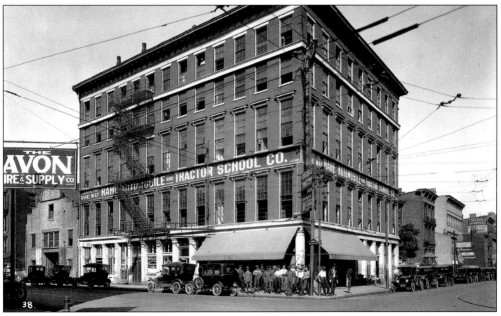

A small crowd from the Rahe Automobile and Tractor School gathers to watch the photographer set up a picture downtown, *circa* 1923 (Photograph by W.T. Myers & Co., courtesy of Bill Myers.)

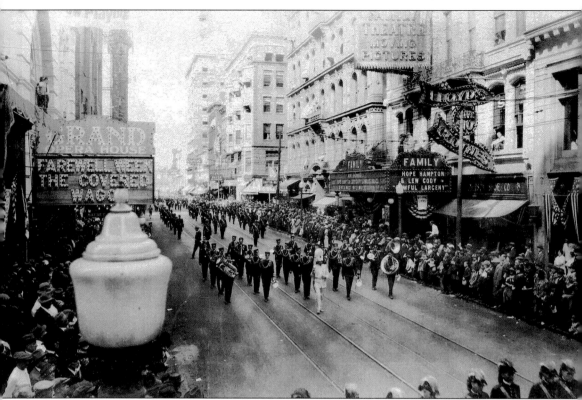

A typical Cincinnati streetlamp stands in the foreground in this view of a parade marching down Vine Street, south of Sixth, in 1923. The Grand Opera House is presenting *The Covered Wagon*, while across the street the Family Theater shows the silent feature *Lawful Larceny* starring Hope Hampton and Lew Cody. (Courtesy of the Fred Bauer collection.)

Vaudeville and photoplays were huge attractions at the Palace theater on Sixth Street in 1928. The theater was currently showing *Square Crooks*. (Photograph by W.T. Myers & Co., courtesy of Bill Myers.)

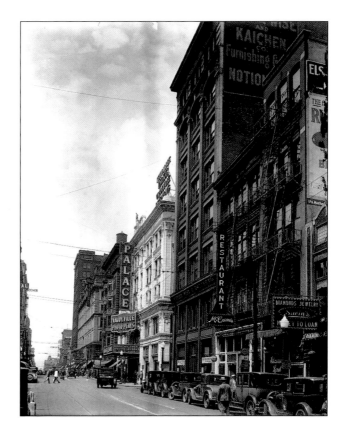

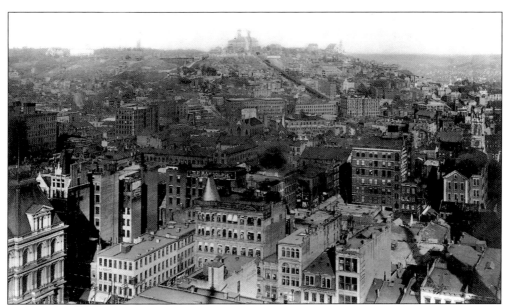

A view from the roof of the Union Central Building at Fourth and Vine in the late 1920s shows the Mount Adams Incline and an array of buildings, most of which have all been lost through the passage of time. (Courtesy of the Cincinnati Chapter NRHS.)

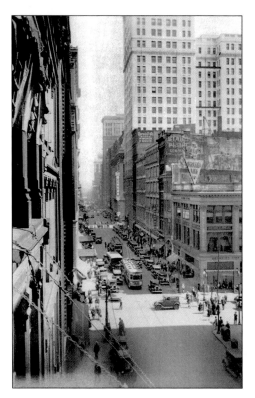

Streetcars and automobiles make their way across Fourth Street in 1928. The Sinton Hotel is visible on Fourth and Vine. (Courtesy of the Fred Bauer collection.)

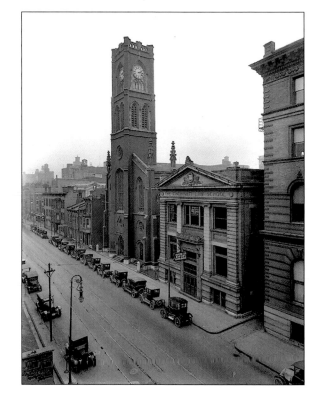

Henry Ford's automobiles were in the majority of the vehicles parked on the sides of Ninth Street, between Race and Elm, *circa* 1922. (Photograph by W.T. Myers & Co., courtesy of Bill Myers.)

As the city moved forward through the 1920s, clothing styles as well as automobile styles changed with the times. Streetcars, however, stayed primarily the same, even by 1930. (Photograph by Ed Kuhr Sr., courtesy of the Dan Finfrock collection.)

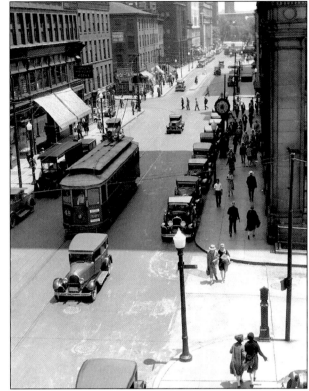

Someone waiting for the streetcar in O'Bryonville would have stood on this loading platform on Madison Road at Torrence Parkway in 1943. The Toddle House straight ahead was famous for its tasty hamburgers. (Courtesy of the Fred Bauer collection.)

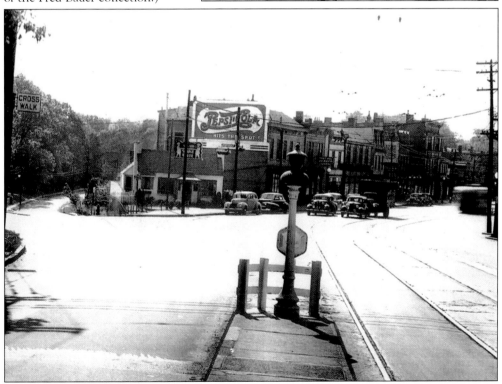

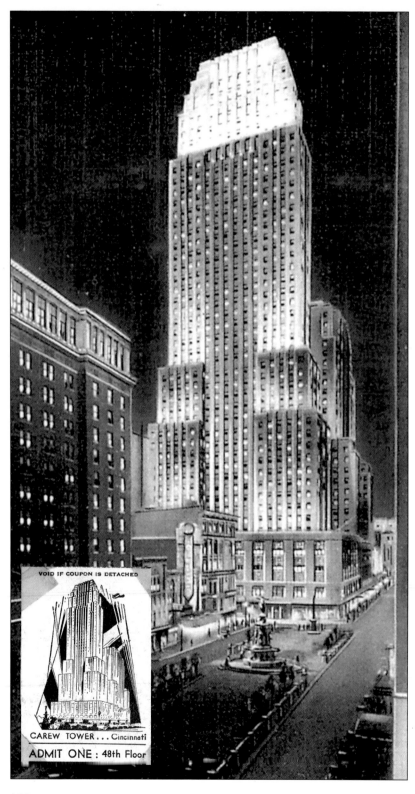

VOID IF COUPON IS DETACHED

CAREW TOWER . . . Cincinnati

ADMIT ONE : 48th Floor

One of the first stops (or last stops) for the out-of-town visitor to the Queen City in the mid-20th century was the Carew Tower. This scene includes, from left to right, the Hotel Gibson, the beauty of the Tyler Davidson Fountain, the Albee Theater, and the art-deco dominance of the Carew Tower itself. (Courtesy of the Sue Erhart Collection.)

(*Inset*) A major attraction of the new Carew Tower in 1930 was the breathtaking panoramic view of Cincinnati's seven hills from the 48th floor's Observation Deck. This ticket is from a 1952 visit to the Observation Deck. (Courtesy of the Larry Fobiano collection.)